IMAGES
of America

ALONG THE
APPALACHIAN TRAIL
WEST VIRGINIA, MARYLAND
AND PENNSYLVANIA

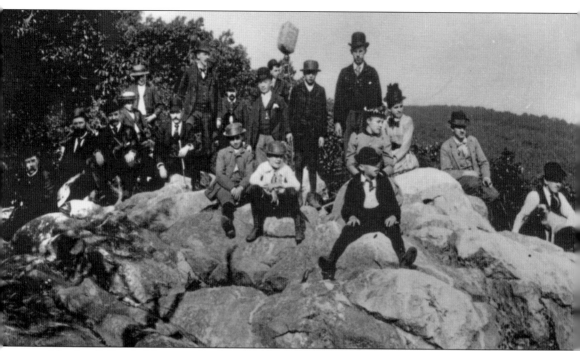

Maryland's South Mountain has been a popular destination since the 1800s. The photograph's exact date is unknown, but photographer John Davis Byerly was active from the 1860s to the 1890s. Born in Pennsylvania, Byerly moved to Frederick, Maryland, in 1842 and became one of the state's first daguerreotypist. (Courtesy of MSA.)

ON THE COVER: Abbie Rowe, a photographer and member of PATC, wrote this caption concerning his 1930s photograph, "Many occupations and professions are represented in the membership of the Washington, DC, Appalachian Trail Club. Here they cover a section of trail in southern Pennsylvania." (Courtesy of PATC.)

IMAGES
of America

ALONG THE
APPALACHIAN TRAIL
WEST VIRGINIA, MARYLAND
AND PENNSYLVANIA

Leonard M. Adkins and the
Appalachian Trail Conservancy

ARCADIA
PUBLISHING

Published by Arcadia Publishing
Charleston, South Carolina

Printed in the United States of America

Library of Congress Control Number: 2014951588

For all general information, please contact Arcadia Publishing:
Telephone 843-853-2070
Fax 843-853-0044
E-mail sales@arcadiapublishing.com
For customer service and orders:
Toll-Free 1-888-313-2665

Visit us on the Internet at www.arcadiapublishing.com

As Myron Avery said, "The trail, as such, will never be completed."
A big thank-you goes to the tens of thousands who labored, and
continue to do so, to make the Appalachian Trail one of America's
finest outdoors resource and the world's most famous footpath.

A portion of the author's royalties from Images of America:
Along the Appalachian Trail: West Virginia, Maryland, and
Pennsylvania will be donated to the Appalachian Trail Conservancy.

CONTENTS

Acknowledgments 6

Introduction 7

1. West Virginia 11

2. Maryland 31

3. Western Pennsylvania 51

4. Eastern Pennsylvania 89

ACKNOWLEDGMENTS

My name may be on the cover, but the following made the book possible: Brian King (ATC), Barbara Wiemann (AHC), Allen Britton (BHC), Rita Flori (BMECC), Richard Tritt (CCHS), Lori Rohrer (DWGNRA), Shanna Klucar (KTA), Maria Day (MSA), Rosalind Suit (MCM), Tom Johnson (PATC), Deborah Lamb (PTC), Sharon Shellenbergr (SATC), Joan March (WTC), and John Seville (YHC). Laurie, you are my inspiration.

KEY TO ABBREVIATIONS USED THROUGHOUT THE TEXT:

AHC—Allentown Hiking Club
ALDHA—Appalachian Long Distance Hikers Association
AT—Appalachian Trail
ATC—Appalachian Trail Conference (Appalachian Trail Conservancy)
BHC—BATONA Hiking Club
BMECC—Blue Mountain Eagle Climbing Club
CCHS—Cumberland County Historical Society
DWGNRA—Delaware Water Gap National Recreation Area
KTA—Keystone Trails Association
MCM—Mountain Club of Maryland
MSA—Maryland State Archives
NPS—National Park Service
PATC—Potomac Appalachian Trail Club
PTC—Philadelphia Trail Club
SATC—Susquehanna Appalachian Trail Club
WTC—Wilmington Trail Club
YHC—York Hiking Club

INTRODUCTION

Although other people had put forth similar ideas, Benton MacKaye's article "An Appalachian Trail: A Project in Regional Planning," which appeared in the October 1921 issue of the *Journal of the American Institute of Architects*, is regarded as having provided the impetus for the Appalachian Trail. MacKaye saw that post–World War I America was becoming urbanized, machine-driven, and removed from the natural world's positive and reinvigorating aspects. In addition to recreational opportunities, he also envisioned the trail connecting a series of permanent, self-sustaining camps where "cooperation replaces antagonism, trust replaces suspicion, emulation replaces competition."

Encouraged by many, MacKaye spread the Appalachian Trail idea to just about anyone who would listen. The idea struck a chord, and in October 1923 the first few miles of trail to be built specifically for the AT were opened in the Harriman-Bear Mountain State Parks of New York by the recently formed New York-New Jersey Trail Conference. The Appalachian Trail Conference (changed to Appalachian Trail Conservancy in 2005) was created in March 1925 as the umbrella organization to oversee efforts to build, maintain, and protect the trail.

With PATC's establishment in 1927, and the appointments (in 1928) of Arthur Perkins as chairman and Myron Avery—a founding member of PATC—as the assistant chairman of ATC, the pace of the trail construction rapidly accelerated. Avery took it upon himself to recruit volunteers and spread the word about the AT. Within four years, PATC had constructed more than 250 miles of trail in Virginia, West Virginia, Maryland, and western Pennsylvania.

In 1916, five years before MacKaye's AT article appeared, Dr. Harry F. Rentschler, a physician from Reading, took an informal group on a hike to an eagle's nest in eastern Pennsylvania. Later that year, he and members of that group formed BMECC. Concerned that construction of the AT in eastern Pennsylvania was lagging, Lafayette College professor Eugene C. Bingham met with the club in 1926 to urge them to begin work on a "Skyline Trail." Rentschler and BMECC rose to the challenge and, despite lack of public land on which to locate the pathway, completed construction of 102 miles of the AT from the Susquehanna River to the Lehigh River by 1931.

Also predating the AT, the Pennsylvania Alpine Club dedicated the Darlington Trail from close to the Cumberland Valley to the Susquehanna River in 1908. The club was one of the original AT maintaining clubs, but when the majority of the Darlington Trail was passed over as a part of the AT, the club felt it needed to remain loyal to its original footpath.

In addition to the clubs that currently maintain the AT in West Virginia, Maryland, and Pennsylvania that are profiled in this book, many other organizations that have overseen the welfare of the trail have come and gone. Among the many in Pennsylvania were the Brandywine Valley Outing Club, which maintained the trail through the Saint Anthony's Wilderness, and the Alpine Club of Williamsport, with maintenance responsibility from Fox Gap to Wind Gap (it currently maintains the 59-mile Loyalsock Trail). Boy Scout Troop 67 oversaw the route from Tri-County Corner to Rausch Gap, and the American Nessmuk Society took care of three miles near Port Clinton, Pennsylvania. The trail between the Delaware Water Gap and Fox Gap has been maintained by several organizations, including BMECC, Lafayette College's Alpha Phi Omega, and Springfield Trail Club. Even businessmen saw the AT's (at least the economic) value as the Delaware Water Gap Chamber of Commerce once helped maintain the trail through their region.

On August 14, 1937, less than 16 years from the publication of MacKaye's article, the AT was a reality, a continuously marked footpath from Georgia to Maine. This feat is made more remarkable when it is remembered that nearly every bit of effort expended was done so by volunteers whose only real motivation was a love of the outdoors and whose sole compensation was the satisfaction of having contributed to the successful completion of such a noble project.

America's attentions were, of course, concentrated elsewhere during World War II, and the trail fell into disrepair and became displaced along many miles of its route. Recognizing the fragility of the pathway, Daniel Koch (a member of the ATC board, president of the Blue Mountain Eagle Climbing Club and, most importantly, an elected member of Congress) introduced, in 1945, legislation in the House of Representatives to establish a system of federally protected footways. Unfortunately, the bill never made it out of committee. The same was true for similar legislation introduced in 1948.

Yet, as often seems to be the case throughout human history, just when things are looking bleak, a popular hero arises whose exploits will arouse and inspire people to take the necessary actions. In 1948, Earl V. Shaffer became the first thru-hiker by walking the entire 2,050-mile route from Georgia to Maine in a continuous four-month trek. Shaffer, an unassuming man from Pennsylvania, did not undertake the journey to set any records, merely to enjoy his time in the mountains and help put his memories of service in World War II in perspective.

Because the accomplishment of his feat was so hard to believe, many people in the trail community, including MacKaye and Avery, doubted that Shaffer had actually walked the entire length of the trail. Only after submitting a detailed daily account of his trip, showing hundreds of slides he had taken along the way, and submitting to hours of grueling questioning was Shaffer proclaimed the first thru-hiker by ATC.

In 1951, twenty-four-year-old Gene Espey of Georgia became the second man to thru-hike the AT, duplicating Shaffer's hike in the same amount of time, four months. As far as records can tell, Mildred Norman Ryder became the first woman to thru-hike in 1952, by hiking northward with a male companion to the Susquehanna River and then the two of them taking motorized transportation to Mount Katahdin to walk southward back to Pennsylvania.

The Appalachian Trail that you and I walk today is a very different pathway than the one followed by hikers in decades past. When first constructed, it went across miles of private property with the permission of landowners who lived and farmed on and near the crest of the mountains. In addition, multiple miles followed roads, sometimes for expediency and sometimes because landowner permission could not be obtained. Also, through the years, the trail faced additional threats to its integrity, such as utility line rights-of-way, resort and housing developments, road construction, and other modern world destructions. The National Trails System Act was passed in 1968 and designated the AT and Pacific Crest Trail as the country's first two national scenic trails. Providing further protection, the Appalachian Trail Act was signed into law on March 21, 1978, by Pres. Jimmy Carter. At that time, less than 1,250 miles of the trail were in the public trust. The act appropriated $90 million in federal funds to purchase—over the next several years—the needed acreage to remove the remaining 900 or so miles off roadways and private property. This effort has been so successful that in 2014 less than three miles of trail remained to be protected.

Showing its faith in the capabilities of the volunteers and staff of ATC, the National Park Service delegated much of the responsibility of managing the Appalachian Trail to ATC in January 1984. This meant that, even though federal monies were being used to purchase land for the trail, its day-to-day affairs would still be overseen by those who are most closely associated with it.

Because of the makeup of its organization, ATC could in turn relegate the vast majority of its responsibility for caring for the footpath on the ground to the volunteers of the local trail clubs. Volunteers have always been the backbone of the AT and in many ways may be more valuable to the trail than ATC. Even to this day, it is volunteers who perform the bulk of trail maintenance, devoting weekends and other spare time to relocating, rebuilding, and keeping the pathway clear of undergrowth and blowdowns. (During fiscal year 2014, nearly 6,000 volunteers from the local maintaining clubs contributed approximately 245,500 hours of trail-related labor.)

In addition to physically working on the trail, volunteers also make up the boards of most of the local trail clubs, devoting numerous evenings and days sitting through meetings to insure that their sections of trail remain in the best shape possible.

Under the 1984 ATC/NPS agreement, volunteers took on new responsibilities, which include monitoring the trail lands for any problems such as encroachment, development, timbering, and the like, or illegal use by motorized vehicles or bicycles. Sometimes volunteer efforts do not come

in the form of weed whacking or local club functions but individuals whose simple love of the AT causes them to respond to situations that threaten to destroy the integrity of the trail, such as when a proposed racetrack close to the trail in Pennsylvania was defeated after authorities heard multiple voices raised in protest.

In many ways, the AT is also becoming a victim of its own successes. Increasingly, the jobs of ATC, the NPS, local maintaining clubs, and other managing agencies have had to focus on ways to manage and minimize the impact of rapidly rising numbers of people who come to hike on the trail. It took from the inception of the AT in the 1920s to the early 1980s for the first 1,000 people to hike the entire trail. Now, in the span of a few decades, the number of officially certified 2,000-milers has risen to more than 15,000 and will most likely reach 20,000 soon.

It is not only thru-hikers who are on the increase. ATC's estimate is that more than two million people make use of some portion of the trail annually. The challenge is not only how to protect the actual physical aspects of the trail from such numbers, but also how to preserve the quality of the trail experiences of those who come in search of the tranquil beauty that the trail can provide.

As is true with anything worth creating and preserving, it takes constant vigilance and work to keep the Appalachian Trail protected and a place of beauty, or as Myron Avery stated, "The trail, as such, will never be completed." Those who came before did their part. Think of the satisfaction—and sense of being a part of something known throughout the world—you would have by becoming a member of ATC and one or more of the local clubs. In addition, join a work trip to build, maintain, and protect a section of this marvelous route through the narrow strips of wilderness remaining within the eastern United States.

Appalachian Trail Conservancy
P.O. Box 807, Harpers Ferry, WV 25425-0807
(304) 535-6331
www.appalachiantrail.org

Outdoor Club of Virginia Tech
Blacksburg, VA
www.outdoor.org.vt.edu
Maintains the AT along the West Virginia/Virginia border on Peters Mountain near Pearisburg, Virginia

Potomac Appalachian Trail Club
118 Park Street SE, Vienna, VA 22180-4609
(703) 242-0315
www.patc.net
Maintains more than 230 miles of the trail in sections from Rockfish Gap in Virginia through West Virginia and Maryland to Pine Grove Furnace State Park, Pennsylvania

Mountain Club of Maryland
7923 Galloping Circle, Baltimore, MD 21244
(410) 377-6266
www.mcomd.org
Maintains the nine northern-most miles of the trail in Maryland, and from Pine Grove Furnace State Park to Center Point Knob and from Darlington Trail to the Susquehanna River, Pennsylvania

Cumberland Valley Appalachian Trail Club
P.O. Box 295, Boling Springs, PA 17007
www.cvatclub.org
Maintains approximately 17 miles from Center Point Knob to the Darlington Trail, Pennsylvania

York Hiking Club
York, PA
www.yorkhikingclub.com
Maintains close to seven miles from the Susquehanna River to PA 225, Pennsylvania

Susquehanna Appalachian Trail Club
P.O. Box 61001, Harrisburg, PA 17106-1001
www.satc-hike.org
Maintains more than 20 miles from PA 225 to Rausch Gap Shelter, Pennsylvania

Blue Mountain Eagle Climbing Club
P.O. Box 14982, Reading, PA 19612
www.bmecc.org
Maintains 65 miles from Rausch Gap Shelter to Tri-County Corner, and from Bake Oven Knob Road to Lehigh Furnace Gap, PA

Allentown Hiking Club
P.O. Box 1542, Allentown, PA 18105-1542
www.allentownhikingclub.org
Maintains approximately 10 miles from Tri-County Corner to Bake Oven Knob Road, Pennsylvania

Philadelphia Trail Club
Philadelphia, PA
www.philadelphiatrailclub.org
Maintains 10 miles of the AT from Lehigh Furnace Gap to Little Gap, Pennsylvania

Appalachian Mountain Club-Delaware Valley Chapter
Bethlehem, PA
www.amcdv.org
Maintains 15 miles from Little Gap to Wind Gap, Pennsylvania

BATONA Hiking Club
Philadelphia, PA
www.batona.wildapricot.org
Maintains slightly more than 8 miles from Wind Gap to Fox Gap, Pennsylvania

Wilmington Trail Club
P.O. Box 526, Hockessin, DE 19707-0526
(302) 652-6881
www.wilmingtontrailclub.org
Maintains seven miles from Fox Gap to Delaware Water Gap, Pennsylvania

Note: When putting this book together, it became obvious that with the many route changes the Appalachian Trail has experienced, it would be impossible to arrange the photographs merely in chronological or geographical order. Therefore, I have used a combination of the two, with older routes coming before the newer ones and the photographs arranged in a chronological order along each route.

One

WEST VIRGINIA

The AT first comes into contact with West Virginia along the state's southeastern border with Virginia, east of Peterstown. However, this did not happen until the mid-1950s. Prior to that, the trail followed the Blue Ridge Mountains through Virginia, but the Blue Ridge Parkway's construction, begun in the 1930s, displaced so much of the trail that volunteers rerouted the pathway to the west onto lands recently obtained by the Jefferson National Forest in the Allegheny Mountains. After crossing the New River at Pearisburg, Virginia, the route traverses Peters Mountain, zigzagging across the states' border line for approximately 10 miles. Before dropping off the mountain into Virginia, it passes the southern terminus of the Allegheny Trail, West Virginia's premier long-distance pathway.

After 360 miles in Virginia, the AT again follows a ridgeline weaving along the West Virginia-Virginia border, beginning at Keys Gap, east of Charles Town. Only about four miles are located entirely in West Virginia, and stone foundations along the pathway are vestiges of Civil War fortifications while, descending into the state, the trail passes charcoal pits from the 1800s. Crossing the Shenandoah River, it enters Harpers Ferry, Virginia, headquarters of ATC.

The small town has been the scene of major events throughout the country's history. On his way to the Continental Congress in 1783, Thomas Jefferson proclaimed the Potomac and Shenandoah Rivers' confluence a scene "worth a voyage across the Atlantic." In 1794, George Washington convinced Congress to establish a federal arsenal and armory on the site, and Meriwether Lewis was so impressed with its quality munitions that he obtained its rifles for his expedition into the Louisiana Territory. And it is said John Brown's failed raid on the arsenal to obtain arms for a slave insurrection in 1859 was the Civil War's opening act.

The AT leaves West Virginia and enters Maryland by utilizing a footway attached to a railroad bridge across the Potomac River.

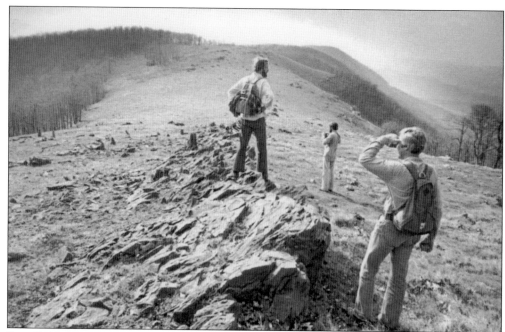

Rice Field along the West Virginia-Virginia border provides hikers with spacious western views. Cattle graze directly below (and had once pastured in Rice Field), and rectangular fields of farms alternate with woodlands, turning the landscape into a patchwork quilt of colors. Receding into the horizon is a jumble of West Virginia mountaintops. (Courtesy of ATC.)

Members of ALDHA and the Kanawha Trail Club take a break during a joint work trip to maintain the trail on Peters Mountain in 1983. The club, based in Charleston, West Virginia, is no longer an AT maintaining organization, and this section of trail is now overseen by the Outdoor Club of Virginia Tech. (Courtesy of Leonard M. Adkins.)

Photographed by Rima Farmer in 1984, Symms Gap Meadow was witness to Virginia militiamen crossing Peters Mountain on their way from Fincastle, Virginia, to engage Shawnee and Mingo Native Americans at the Battle of Point Pleasant, West Virginia, during Lord Dunmore's War in 1774. From here, the trail soon leaves Peters Mountain and travels hundreds of miles through Virginia. (Courtesy of ATC.)

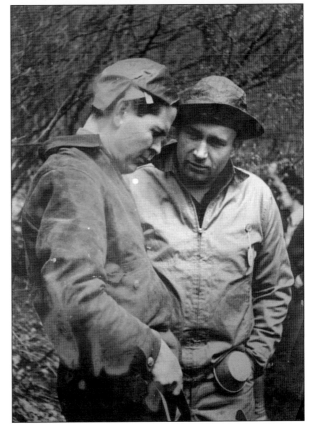

In the 1930s, O.O. Heard, trails supervisor of MCM (and later the club's president), met with Myron Avery, who founded PATC in 1927, to discuss trail-related issues. In 1936, Avery became the AT's first 2,000-miler, having surveyed, measured, or marked every mile of the trail—whether it had been built or not. (Courtesy of ATC.)

13

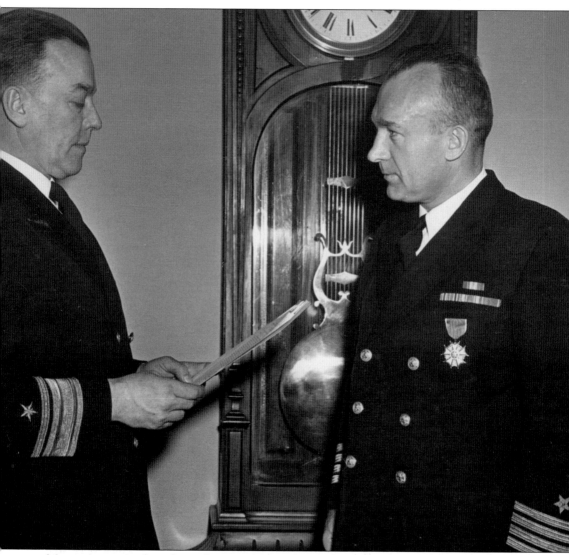

Myron Avery may have been the most active of AT volunteers. He served as PATC's president from 1927 to 1940, was on ATC's board of managers and executive committee as well as conference chairman from 1931 to 1952, and functioned as the Maine Appalachian Trail Club's trails supervisor from 1935 to 1949 and president from 1949 to 1952. Yet, during all of this time, Avery, a Harvard University Law School graduate, held a variety of full-time jobs. During World War II, he was a US Navy officer. After the war, Captain Avery received the Legion of Merit Award from Vice Adm. O.S. Colclough. Due to his efforts to streamline, reorganize, and get legislation passed to change Navy procedures, he saved the government "vast sums of money, a huge post-war accumulation of admiralty litigation has been avoided, vital secrets of the Navy's conduct of the war upon the high seas have been safeguarded . . . and a permanent Navy procedure for the effective handling of admiralty claims has been instituted." (Courtesy of ATC.)

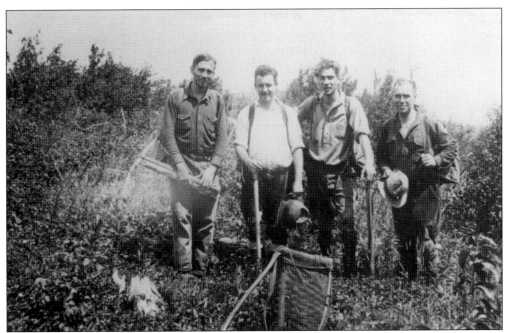

A trail crew was photographed in 1930 by J. Frank Shairer, PATC's first treasurer from 1927 to 1930 and the club's supervisor of trails from 1931 to 1943. Note the item in the foreground; wicker baskets such as this were a popular choice for backpacks during the trail's early days. (Courtesy of PATC.)

Piles of rocks and barely discernible trenches mark the site of Civil War fortifications on the AT's passage of Louden Heights along the West Virginia-Virginia border east of Harpers Ferry, Virginia. The earthworks were built by Union troops defending the town, but they fell to Stonewall Jackson's troops in September 1862. (Courtesy of ATC.)

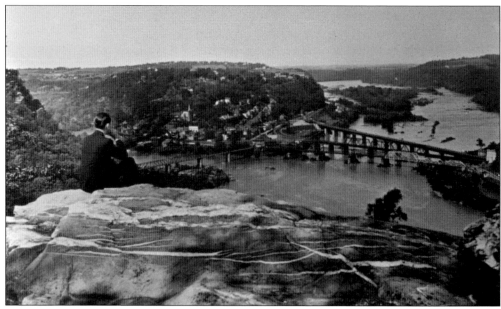

This view of Harpers Ferry from Louden Heights was on the first section of trail constructed by PATC, but because of an AT relocation in the mid-1980s, the vista is now reached via a side trail. The photograph was taken before 1936, as the bridge over the Shenandoah River, which the trail had used, was washed away by a flood that year. (Courtesy of ATC.)

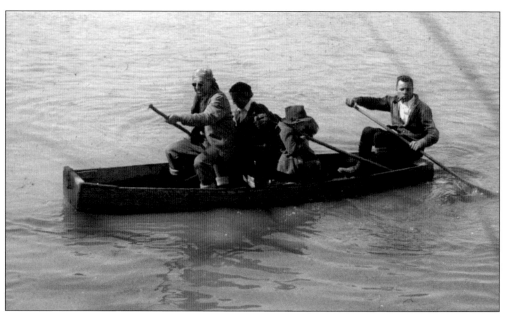

On a hike to Harpers Ferry, members of MCM used the canoe ferry that was the official route of the AT after the 1936 flood that destroyed the Shenandoah River Bridge. The ferry cost 10¢, and one of the hike participants noted there was fierce competition between ferry operators, who were "often inebriated and surly." (Courtesy of MSA.)

A group of hikers took a bus from Washington, DC, in the winter of 1946–1947 to walk from Snickers Gap (near Bluemont, Virginia) to Harpers Ferry. This photograph was most likely taken a few miles north of the gap where the AT enters West Virginia's eastern panhandle. (Courtesy of Sabra Baker Staley and ATC.)

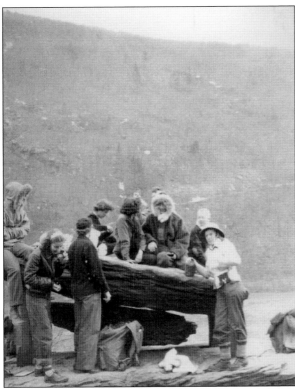

This group pauses at Jefferson Rock, the view from which Thomas Jefferson wrote about in his 1785 *Notes on the State of Virginia*: "The passage of the Potowmac [sic] through the Blue Ridge is perhaps one the most stupendous scenes in nature." (Courtesy of Sabra Baker Staley and ATC.)

After being established in 1925, ATC had its headquarters in Washington, DC, for close to five decades. For a while, it shared space with PATC. Before moving to Harpers Ferry in 1972, the last place ATC occupied in the nation's capital was a row house at 17 North Street NW. (Courtesy of ATC.)

From August 1972 to August 1976, ATC's headquarters was the Brackett House, located on Camp Hill within Harpers Ferry National Historical Park. The house was built in 1858 as the home of the clerk to the superintendent of the Harpers Ferry Armory. It was later named for Dr. Nathan Brackett, the first principal of Storer College. (Photograph by P.H. Dunning; courtesy of ATC.)

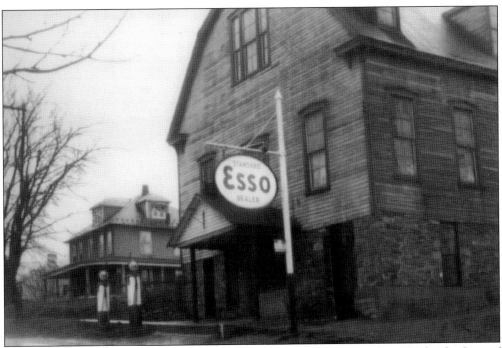

The building that became ATC's headquarters in 1972 was constructed in 1892 by the Sons of Jonadab, a temperance group hoping to counteract the influences of Harpers Ferry's 13 taverns. Later, it served as a private school, town hall, opera house, and Pop Trinkle's soda counter. In the 1930s, it was Thayers Garage, where local children skated on the third floor and played basketball on the second. (Courtesy of ATC.)

In 1948, a dynamite blast (miles away) shattered many of the building's windows and, because the landlord at the time failed to do anything to protect the top floor from the weather, it was later removed so that its deteriorating condition would not affect the rest of the structure. (Courtesy of ATC.)

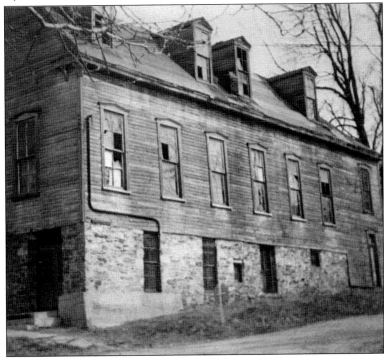

During the 1950s, after having been the Interwoven Sock Company mill, the building was used as a gift shop, apartment, and private resident, and it looked much like it did when ATC relocated. This was the first property purchased by ATC and, owing to the organization's sound fiscal policies, the mortgage was paid off in 20 years. (Courtesy of ATC.)

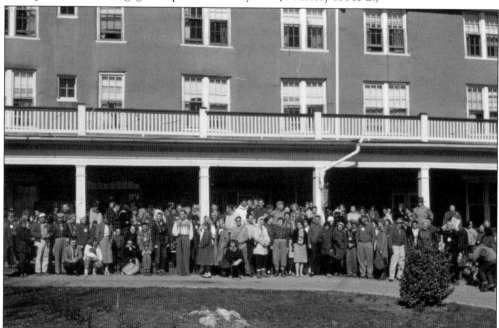

A dozen years before ATC relocated to Harpers Ferry, scores of people attended a Multi-Club Meet at the town's Hilltop House in 1960. The meetings waned for a few years but are currently held again and are primarily a social function enabling trail enthusiasts to make new friends, rekindle older relationships, and catch up on trail news. (Courtesy of MSA.)

Jean Cashin was ATC's second employee, hired in 1972 as information specialist. Upon her 2013 death, her successor, Laurie Potteiger, wrote, "She was often referred to as 'the face of ATC' and 'Trail Mom.' For 24 years she greeted every hiker and visitor, often making them feel like long-lost family members. Any hiker who looked like they needed a hug got one . . . no matter how dirty or smelly." (Courtesy of ATC.)

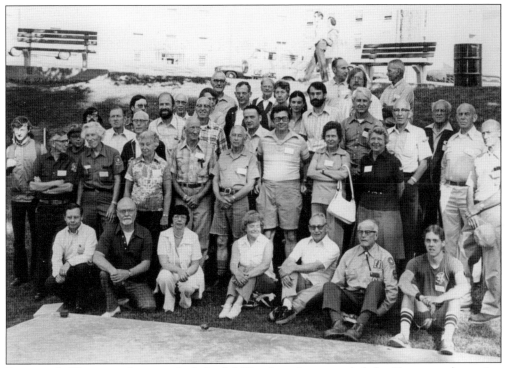

Emerson L. Harrison photographed the 2,000-milers that attended the 21st general meeting of ATC held in Shepherdstown from May 28 to 30, 1977. At that time, this group of less than 50 accounted for more than 10 percent of the people who had hiked the trail's entire length. (Courtesy of ATC.)

After the 1968 National Scenic Trails Act gave the National Park Service administrative responsibility for the AT, it opened the Appalachian Trail Project Office (ATPO), which moved its headquarters to Harpers Ferry in 1978. In the office are, from left to right, (seated) Carol Leone; (standing) Sandra Campbell, Pamela Underhill (the second ATPO manager), and David Richie (the first ATPO manager). (Courtesy of ATC.)

Brian King was photographed during ATC's 75th anniversary celebration. He began working with the *Appalachian Trailway News'* editor in 1979, served on the board's public relations committee, was hired as the director of public affairs in 1987, and in 2005 became ATC's publisher, overseeing the publishing, purchasing, and distribution of trail-related material. He is also author of *The Appalachian Trail: Celebrating America's Hiking Trail.* (Courtesy of ATC.)

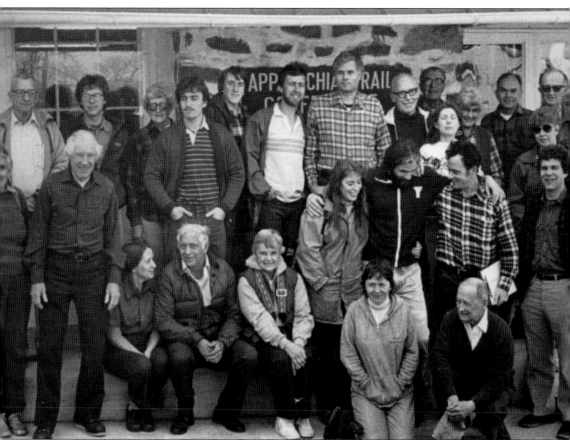

A gathering of 2,000-milers, organized by Warren Doyle, met at the Appalachian South Folklife Center in Pipestem, West Virginia, in October 1982. During the weekend, it was decided to create an organization to represent the thoughts and feelings of those who have hiked the entire trail, enable them to remain in touch while not hiking, and assist in the maintenance and protection of the trail. More than two dozen attended the following meeting in March 1983 at Harpers Ferry that formally created ALDHA. Pictured here are, from left to right, (first row) Ginger Doyle and Thurston Griggs; (second row) Ruth Blackburn, Ed Garvey, Gail Miller, Charles Alsobrook, Violet MacPhee, Cindy Ross, Albie Pokrob, Warren Doyle, and Larry Van Meter; (third row) Wayne Sellman, Don Pelletier, Laura Cramer, Steve Markiewicz, Peter Montgomery, Ron Tipton, Dave Sherman, Bob Pennington, Lester Holmes, Mimmi Eller, Jean Cashin, Dave Ritchie, Bonnie Shipe, and Sam Waddle. (Courtesy of ATC.)

Eric Ryback hiked the entire AT in 1969 when he was only 17 years old. In 1970, be became the first person to walk the Pacific Crest Trail through California, Oregon, and Washington. Two years after that, he hiked the Continental Divide Trail from Canada to Mexico, thereby becoming what is known as hiking's first Triple Crowner. (Courtesy of ATC.)

At a time when there were no low-cost accommodations in Harpers Ferry, Clara Cassidy permitted hikers to camp in her backyard in the 1970s and 1980s. A poet and writer, she invited the travelers into her home for readings and stimulating intellectual conversations. Her books include *Living the Topmost Years: A Compilation of Letters from Clara Cassidy* and *Off My Rocker and Up in Years*. (Courtesy of ATC.)

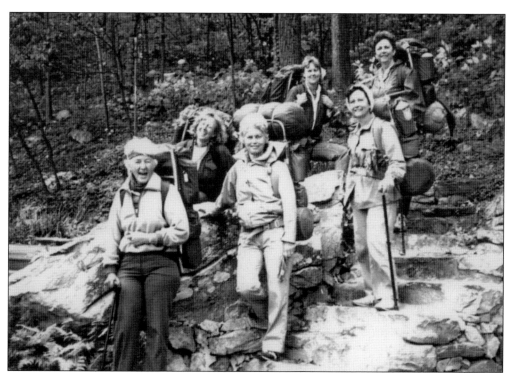

Possibly more dedicated than thru-hikers to becoming 2,000-milers are those who use their two-week vacation every year to complete the trail's full length. The most dedicated may be the Mountain Marching Mamas, six women from Florida who began walking the AT in 1978 and completed it 20-some years later. Their experiences are chronicled in *It's Always Up: Memories of the Appalachian Trail.* (Courtesy of ATC.)

In order to protect scenic views and the trail's wilderness nature outside the protected corridor, the Trust for Appalachian Trail Lands (now called the ATC Land Trust) was established in 1982. Bob Williams was hired as the land trust coordinator in July 1994 and served in that position until December 2005. (Courtesy of ATC.)

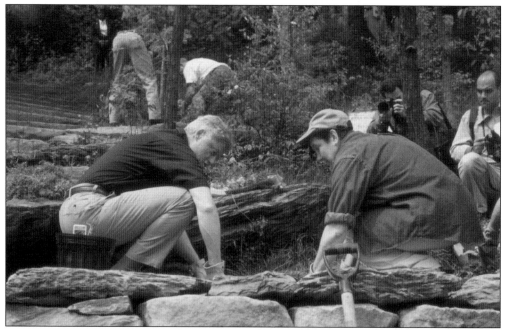

On Earth Day, April 22, 1998, Pres. William Jefferson Clinton (left) aided ATC Mid-Atlantic regional director Karen Lutz (right) in rehabilitating the trail in Harpers Ferry close to the site—Jefferson Rock—named for the person from whom Clinton received his middle name. Clinton truly joined in the work, going so far as to lift a rock or two. (Courtesy of ATC.)

Vice Pres. Al Gore (right) also worked on the trail with ATC employee Karen Lutz (left). Lutz demonstrated to Gore how to transplant vegetation to help prevent erosion on a popular section of the pathway through Harpers Ferry National Historical Park. Gore and Clinton are America's only vice president and president to ever physically work on the AT. (Courtesy of ATC.)

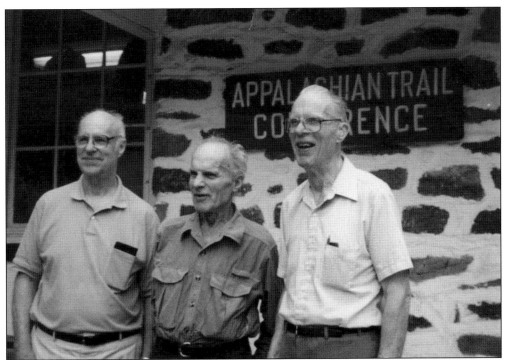

On the 50th anniversary of his first thru-hike, Earl Shaffer (above, center) undertook his third thru-hike in 1998 and was joined by his brothers John (left) and Dan (right) in Harpers Ferry on July 16. ATC celebrated with a specially decorated cake (right) and several events and testimonials. Shaffer completed the thru-hike in 174 days on October 21, turning 80 years old two weeks later. He passed away on May 4, 2002, from complications of cancer and was inducted into the Appalachian Trail Museum's AT Hall of Fame as a charter member on July 27, 2011. His book, *Walking with Spring*, is an account of his first thru-hike and is based on the journal he kept during the trek. (Both, courtesy of ATC.)

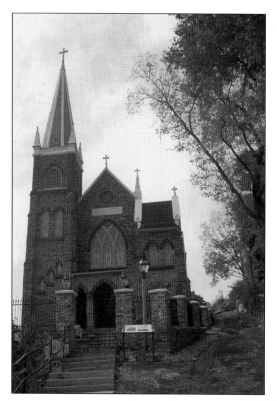

Harpers Ferry was designated a national monument in 1944 and became Harpers Ferry National Historical Park in 1963. The AT runs directly beside St. Peter's Catholic Church, constructed from 1830 to 1883 and one of the most prominent features of the town when viewed from the AT's former route along Louden Heights. (Courtesy of ATC.)

The hand-cut stone steps that the AT makes use of to descend from Jefferson Rock to the trail's crossing of the Potomac River were built in the early 1800s. The individual steps have depressions in them, and their surfaces have been worn smooth from the hundreds of thousands of feet that have trod on them in the ensuing years. (Courtesy of Leonard M. Adkins.)

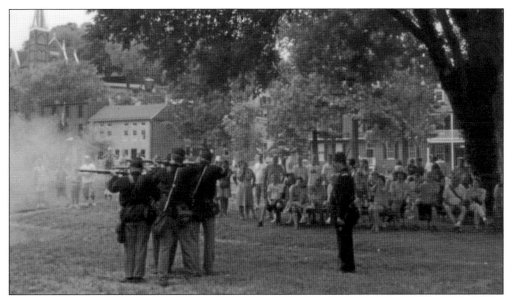

On the border of the North and South with a munitions arsenal and rail and water transportation, Harpers Ferry was hotly contested during the Civil War and changed hands eight times. The interpretive programs of the park service include living history demonstrations of those days such as canon and artillery demonstrations. (Courtesy of Harpers Ferry National Historical Park.)

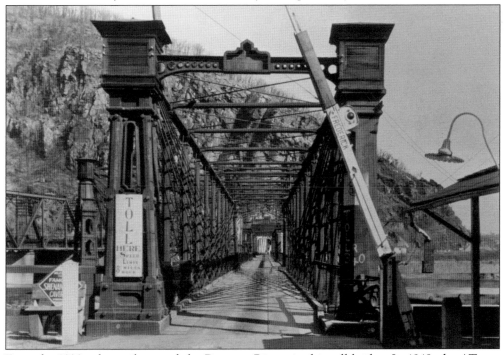

From the 1920s, the trail crossed the Potomac River via this toll bridge. In 1948, the AT was relocated onto the US 340 Sandy Hook Bridge a short distance downstream from the Potomac and Shenandoah Rivers' confluence, taking the trail out of Harpers Ferry. It returned to the town in the mid-1980s, when the pathway was moved from Louden Heights and onto the newer Shenandoah River Bridge. (Courtesy of ATC.)

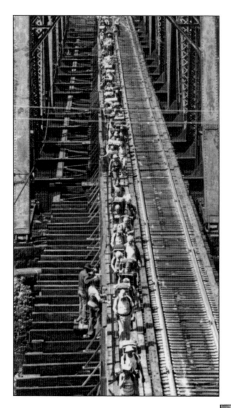

In May 1981, Hike-A-Nation, an organized group that walked from San Francisco, California, to Cape Henlopen, Delaware, crossed the Potomac River on the railroad bridge after following the AT from Damascus, Virginia. Hike-A-Nation was started by the American Hiking Society, in part to call attention to the size of America's hiking community and the need for more trails. (Courtesy of ATC.)

Sen. Robert Byrd from West Virginia and his wife, Erma, attended the Goodloe E. Byron Memorial Footbridge dedication in December 1985. Attached to the railroad bridge, its construction enabled the AT to return to a passage of Harpers Ferry before crossing the Potomac River to enter Maryland. (Courtesy of ATC.)

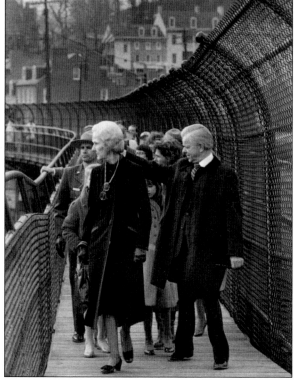

Two

MARYLAND

The AT in Maryland follows a route that has changed very little since J. Frank Shairer scouted it in 1930, and PATC completed its approximately 40 miles a few years later. The reroutes that did occur involved merely moving the trail barely tenths of mile east or west of the original route on South Mountain or taking it off short sections of roadway.

Entering Maryland after crossing the Potomac River, the trail turns eastward along the level route of the Chesapeake and Ohio Canal towpath for several miles before rising to Weverton Cliffs and a view of the Potomac River and Harpers Ferry. Now on South Mountain, which the trail follows throughout Maryland, the AT runs along the ridgeline with little change in elevation. Coming into Crampton Gap, it passes by, as far as can be determined, the only monument in the world to war correspondents.

A few miles north of Crampton Gap, the AT crosses US Alternate 40, whose route was originally constructed by British forces under Gen. Edward Braddock (accompanied by George Washington) to facilitate their march westward. The troops were ambushed, and Braddock was killed by French and Indian troops near present-day Uniontown, Pennsylvania. Improved with funds provided by the State of Maryland, the route became part of the National Road and is said to have carried such luminaries as Pres. Abraham Lincoln, Daniel Webster, Henry Clay, and Presidents Jackson, Harrison, Polk, Taylor, and Van Buren.

North of Turners Gap, the trail goes by viewpoints from Annapolis Rocks, Black Rock Cliffs, and High Rock before entering Pen Mar Park, a popular resort from the 1890s to nearly the mid-1900s. Crossing the Mason-Dixon Line a short distance north of the park, the pathway leaves Maryland and enters Pennsylvania.

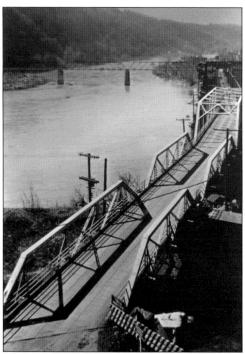

This rare photograph that shows the bridges the AT used to cross the Shenandoah River (center) into Harpers Ferry and Potomac (right) in Maryland was taken before both were destroyed by the 1936 flood. Afterward, a wooden floor was placed on the adjacent Shenandoah Subdivision railroad bridge for automobile traffic. It was used until the construction of the US 340 Sandy Hook Bridge in the 1940s. (Courtesy of ATC.)

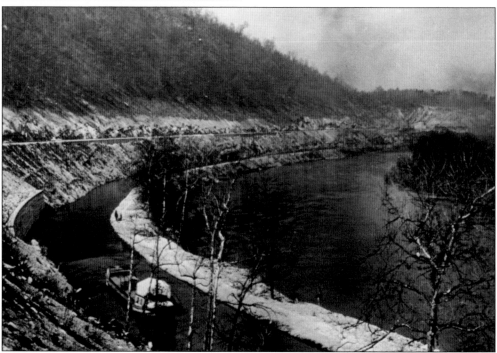

Once in Maryland, the AT turns eastward to follow the Chesapeake and Ohio Canal, shown in this 1870 photograph. By the 1830s, the canal linked Harpers Ferry with Washington, DC. Operations ended in 1924 when a major flood damaged many of its structures. Today, it is the C&O Canal National Historical Park, consisting of more than 180 miles from the nation's capital to Cumberland, Maryland. (Courtesy of HFNHP.)

The AT's first blind hiker, Bill Irwin, and his dog Orient were photographed walking along the C&O Canal in August 1990. His remarkable trek is detailed in his book *Blind Courage* and the video *Amazing Grace*. The journey inspired others, such as Trevor Thomas, the first unassisted blind hiker, who hiked in 2008, and 2014's deaf-blind hiker, Roger Poulin. (Courtesy of ATC.)

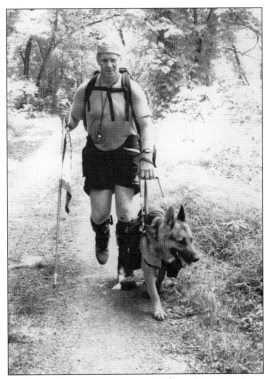

There was more social interaction between maintenance clubs in the trail's early days than there is now. More than 150 people from PATC, MCM, Maryland Appalachian Trail Club, and YHC were at the starting point of a multi-club hike November 11–12, 1939. MCM's first president, Orville Crowder (standing in front of the group), gave instructions. (Courtesy of MSA.)

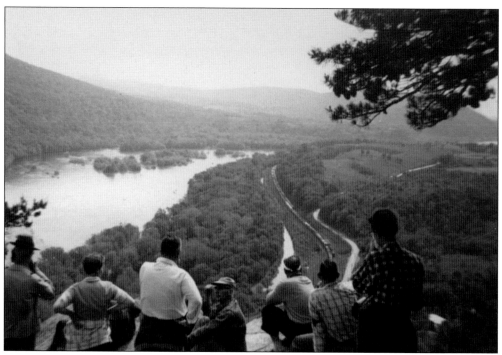

M. Fleming of York, Pennsylvania, photographed a group of hikers on Weverton Cliffs in May 1959. Barely more than an hour's drive from Washington, DC, the view takes in three states—Virginia, West Virginia, and Maryland—and is one of the trail's most popular Mid-Atlantic states' destinations. Directly below are the C&O Canal and the AT. (Courtesy of ATC.)

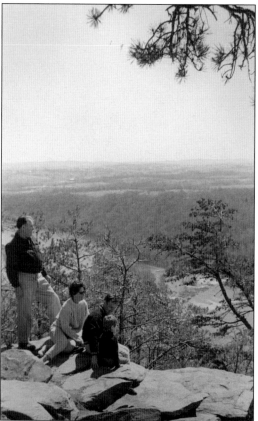

In 1972, ATC executive director Lester Holmes (left), Beverly Byron (seated left), Maryland congressman Goodloe Byron (seated center), and the couple's son Goodloe Byron Jr. ascended Weverton Cliffs for the Potomac River view. Congressman Byron was an ardent AT supporter, and the footbridge attached to the Potomac River railroad bridge is named for him. (Courtesy of ATC.)

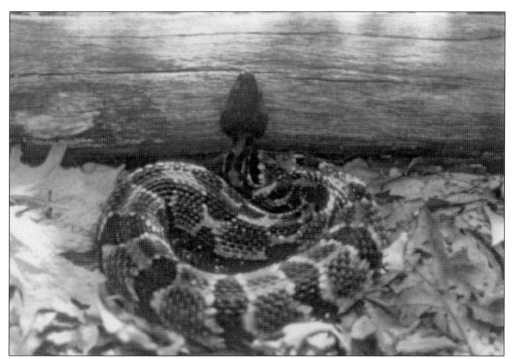

In a reflection of the prevailing common thought of their times, early AT hikers often killed venomous snakes such as this timber rattlesnake, photographed in an attack position. Through education, today's hikers have learned that every creature is an important part of the trail with the right to exist within its own environment. (Courtesy of ATC.)

Members of WTC took a hike from Harpers Ferry into Maryland from May 11 to 13, 1982. On the ground is Jack Dempsey. On the rock are, from left to right, Lee Ann Byles, unidentified, Joan Lynch, Louise McFuesten, Dotty Green, Yvonne Blades, and May Hatchard. The short rock cliff is a geological oddity on the AT, only common in Maryland and Pennsylvania. (Courtesy of WTC.)

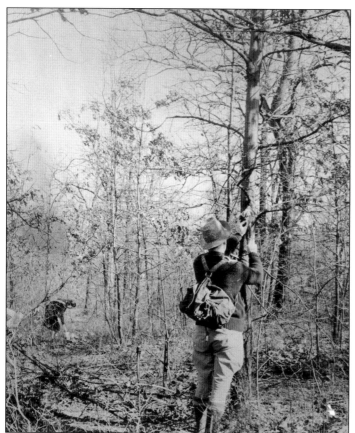

Prolific PATC photographer Howard S. Olmsted took this picture in the 1930s and captioned it, "Work trips include cleaning trail and putting up new metal markers." Many of the original markers were made of copper, eventually replaced by those made of aluminum and then galvanized steel. (Courtesy of PATC.)

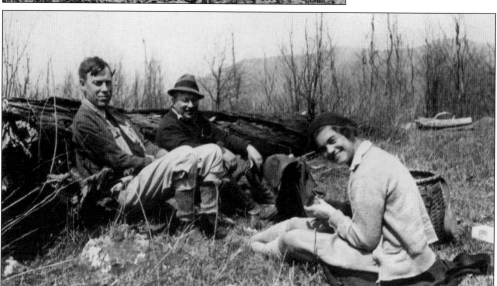

Egbert Walker (left) and Dorothy Walker (right) along with W.A. Dayton (center) were early members of PATC. From the 1930s, the Walkers devoted so much time to the AT and PATC that they were made honorary life members in 1970. Egbert directed the club's maps committee and often worked alongside Myron Avery maintaining the trail in the Mid-Atlantic states. (Courtesy of PATC.)

Ed Garvey hiked the AT in 1970 and attempted a second thru-hike at the age of 70 in 1995. He was so actively involved with the trail, ATC, and PATC that the latter dedicated a shelter in Maryland in his honor two years after he passed away in 1999. His two books, *Appalachian Hiker* and *The New Appalachian Trail*, garnered much publicity for the AT. (Courtesy of ATC.)

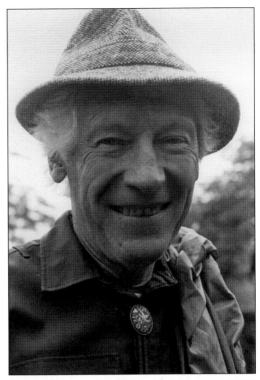

Wisconsin senator Gaylord Nelson (left) introduced a 1964 bill to federally protect the AT. The bill went through several revisions, and its original scope was expanded. Nelson's intentions became reality when the National Trails System Act was passed and signed into law by Pres. Lyndon B. Johnson in 1968. Nelson was photographed here in his later years with ATPO manager Pamela Underhill. (Courtesy of ATC.)

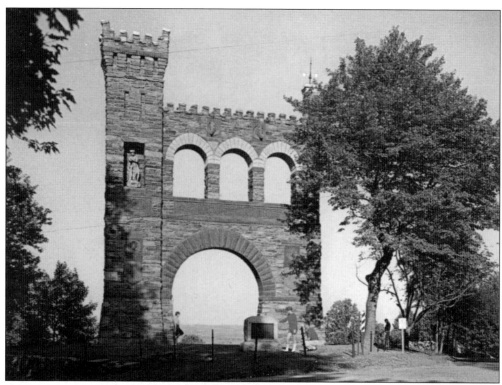

The War Correspondents' Memorial is beside the AT in Crampton Gap, Maryland. Commissioned in 1885 by George Alfred "Gath" Townsend, a journalist from 1866 to 1910, it memorializes Civil War reporters and artists. The off-balance monument contains a large Moorish arch below three smaller ones of Roman design, and it is said it would take hours to look at the dozens of inscriptions and mythological figures. (Courtesy of Kelley's Studios.)

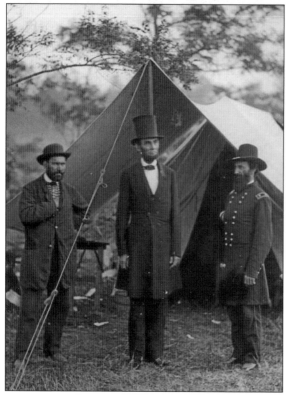

The monument site is appropriate. On September 14, 1862, the Battle of South Mountain raged from Crampton Gap and Fox Gap to Turners Gap. The Union prevailed as Confederates retreated to Antietam Creek (a short distance west of the present-day AT) where the two sides fought during the single bloodiest day of the war. Pres. Abraham Lincoln (center) visited the battlefield less than a month later. (Courtesy of J. Robson.)

Two hikers pose in Crampton Gap in the late 1950s or early 1960s. The directional sign shows that the AT south of here has changed little since then, with Weverton Cliffs still being 6.2 miles away and the US 340 Sandy Hook Bridge approximately 9 miles from the sign. (Courtesy of ATC.)

PATC members Ruth and Fred Blackburn were active in many capacities from the 1930s onward, including both being presidents of PATC and Ruth being ATC chairperson. In 1983, the secretary of the interior stated Ruth "was the single most influential volunteer in shaping the successful National Park Service protection program." Fred was a founding member of KTA and Ruth of ALDHA. (Courtesy of ATC.)

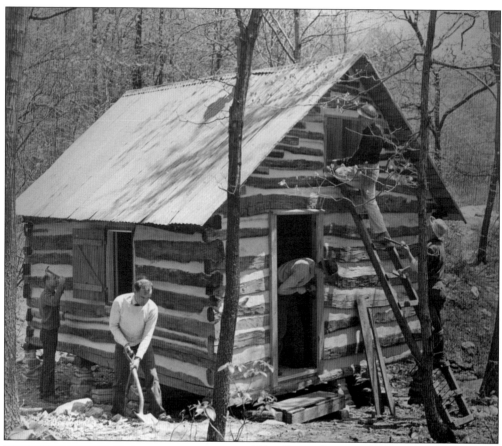

Abbie Rowe photographed PATC volunteers constructing Bear Spring Cabin a short distance north of Crampton Gap in the late 1930s. The club operates a variety of such cabins; some originally constructed to house volunteer crews working on nearby trails, others built by the forest service, and others were homes of mountain families. Most are now available for rent to the general public. (Courtesy of ATC.)

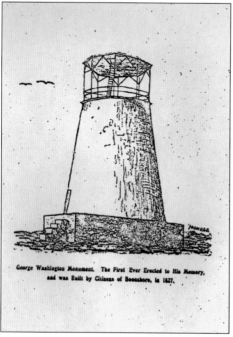

George Washington Monument. The First Ever Erected to His Memory, and was Built by Citizens of Boonsboro, in 1827.

North of Turners Gap, the AT passes below the original Washington Monument, built by citizens of Boonsboro, Maryland, and dedicated in 1827. Constructed without mortar, it began to decay, and the Boonsboro Independent Order of Odd Fellows paid to have it rehabilitated in 1882, complete with a covered steel observation deck. (Courtesy of *History of Washington County, Maryland*, Volume I, by Thomas Williams, ©1906.)

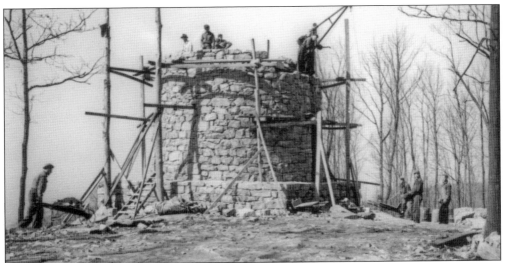

By the 1930s, the Washington Monument had once again begun to deteriorate, and members of the Civilian Conservation Corps, one of Pres. Franklin D. Roosevelt's New Deal projects, were employed to rebuild it. This time, the steel roof was left off, but mortar and other correct construction techniques were used. The monument has needed no major work since then. (Courtesy of ATC.)

Chris Deffler is pictured here below the Washington Monument during his 1982 thru-hike attempt. Part of a band of close-knit fellow hikers that had met each other early in the journey, he was making good progress toward his goal when he died from a fall near Bear Mountain in New York. (Courtesy of Leonard M. Adkins.)

Members of MCM took in the view to the west from Annapolis Rocks in July 1943. The hard quartzite rock outcropping sits about 1,800 feet above the Cumberland Valley; the view of 42-acre Greenbrier Lake is partially blocked by the person on the left. (Courtesy of MSA.)

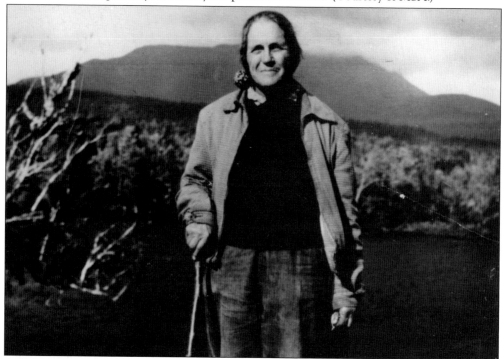

After surviving years of physical and mental abuse and giving birth to 11 children, Emma "Grandma" Gatewood became a trail legend by being the first woman to thru-hike the trail alone, in 1955. She would later become the first person to hike the trail three times, completing her third 2,000 miles in 1963. (Courtesy of ATC.)

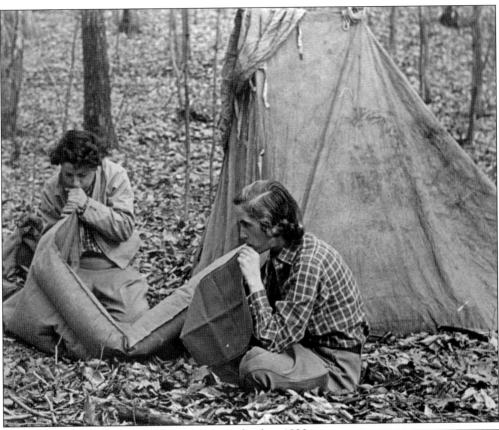

The caption photographer Abbie Rowe gave this late-1930s photograph is, "With a huff and a puff, we'll blow up this air mattress if it takes all night. Vivian Robb Boardman and Ruby Anderson blow in earnest." Air mattresses such as this and the erected tent made of canvas were standard hiking equipment of the day. (Courtesy of PATC.)

Marion Lapp Park was an early treasurer of PATC and spent long hours writing letters Myron Avery would dictate to her late into the night. She was also on ATC's board of managers and purchased and donated Highacre, a home in the residential area of Harpers Ferry, which enabled PATC to have a presence near ATC. (Courtesy of PATC.)

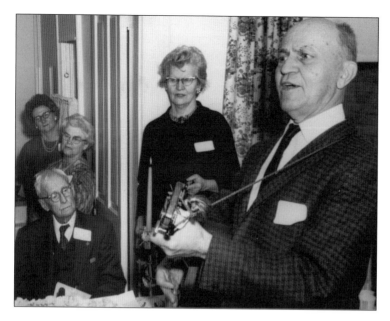

In the 1930s, Joe Wynn (foreground) often provided the musical entertainment for PATC functions and, in fact (along with fiddler Bob Beach), continued to do so for nearly five decades. Wynn joined the club in 1932 and was its programs chairperson for many years. Behind him are D. Walker Gaddis (left) and Purlie Bishop (right). The two women behind them are unidentified. (Courtesy of PATC.)

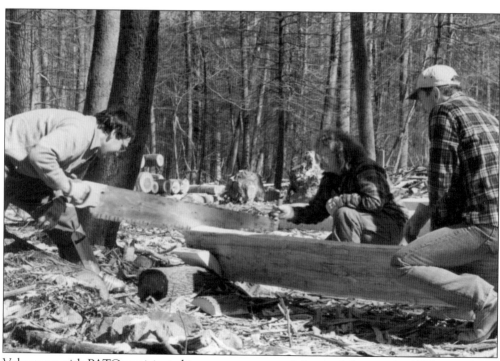

Volunteers with PATC participated in a crosscut saw training workshop in the 1990s in order to be certified to use such instruments along the AT corridor. Although volunteers can also become certified in the use of chain saws, motorized equipment is not permitted in congressionally designated wilderness areas. Certification also provides volunteers with insurance in case of accidents while working in national parks or forests. (Courtesy of PATC.)

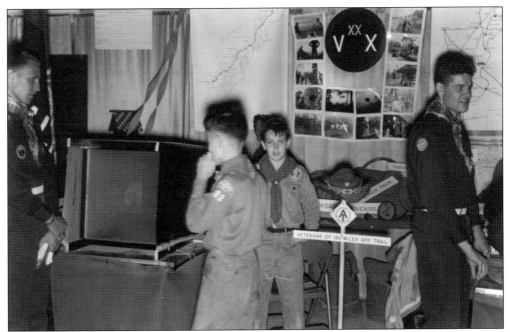

In Timonium, from October 19 to 20, 1956, Boy Scouts of Post 163 proudly displayed the maps and equipment used during 160 miles of hiking on the AT. Scouts often use the trail to meet the 50-Miler Award requirements—making the plans for the trip, hiking 50 consecutive miles in a minimum of five consecutive days, and completing 10 hours of trail work. (Courtesy of ATC.)

M. Gentry photographed David Startzel (left) and Tom Johnson (right) discussing AT matters in July 1995. Startzel became an ATC staff member in 1978, associate director in 1981, and executive director in 1986, a position he held until retirement in 2012. Among the many volunteer positions Johnson has held are PATC president, overseer of PATC archives and library, and chairman of the Great Eastern Trail Association. (Courtesy of PATC.)

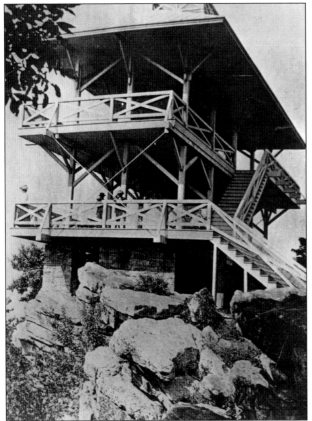

Thurston Griggs joined MCM in 1959 and spent five decades volunteering to help build, maintain, and protect the trail. He was the club's president from 1972 to 1974 and again from 1990 to 1992, first editor of ATC's newsletter for maintainers the *Register*, maintainer of more than three miles of trail, and one of the trail's first ridge runners, educating visitors in minimum impact camping and hiking techniques. (Courtesy of ATC.)

The High Rock Observatory was built in the 1870s and served as a popular destination for Pen Mar Park visitors. In 1883, J. Thomas Scharf wrote, "As far as the eye can reach, the valley is thickly studded with towns, villages, hamlets, and farmhouses, and the landscape consists of undulating plains, silvery streams, projecting mountain peaks." (Courtesy of Virginia Bruneske and ATC.)

Due to deteriorating conditions, the High Rock Observatory was pulled down in 1939. Less than a year later, a group of hikers visited the site, and Ruth Mersett gave the photograph the caption, "March 30, 1940. Taken on Trip #7 at High Rock near Pen Mar. Related by many—what with wind, rain, sleet, and snow—as being the worst day in which they ever went for a hike. However, they went and are hereby recorded." Parasailing became popular in the 1970s and 1980s, and hikers often encountered enthusiasts using High Rock as a launching platform. For years, the AT descended the road to Pen Mar Park. Near the turn of the 21st century, the trail was relocated onto a boulder field for the descent. (Both, courtesy of ATC.)

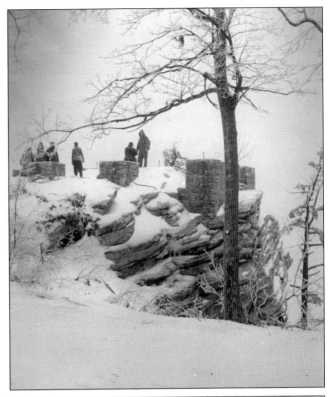

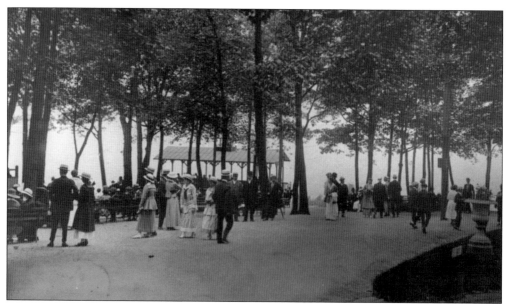

Pen Mar Park appears to be a small community picnic grounds today, but it was a popular resort that opened in 1877 and operated for 65 years. Seven hotels and close to 100 guest cottages catered to daily crowds of 5,000 or more drawn to its amusement park, dance pavilion, dining options, and outstanding Cumberland Valley views. In the 1920s, visitors strolled along the main promenade (above); the AT goes by the pavilion seen in the background. In 1906, newly arrived visitors walked into the park from the Western Maryland Railroad tracks (below). The company created the park as a way to increase ridership, but by the early 1930s, people primarily arrived by personal automobiles. Gas rationing during World War II forced the park to close in 1943. (Both, courtesy of Virginia Bruneske and ATC.)

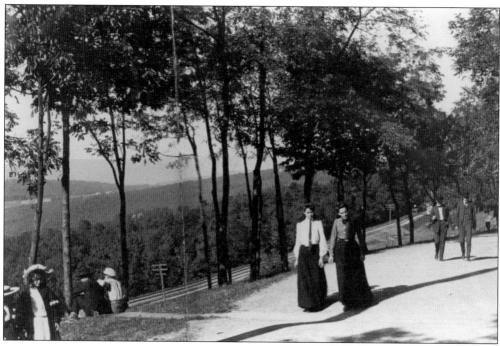

Coyotes are probably newcomers to the Appalachian Mountains. Although there have been reports of coyote-like animals in the eastern United States since the first colonists arrived, most experts conclude the sightings were of gray wolves. Coyotes were first confirmed in eastern America in the 1920s and have now spread to every state along the AT. (Photograph by Justin Matherne; courtesy of ATC.)

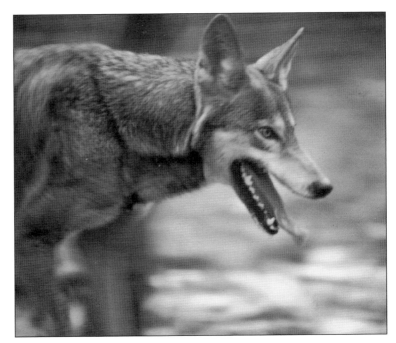

It took several years to relocate the trail between High Rock and the main section of Pen Mar Park. Among the many that volunteered to do the hard work through the rock field were, from left to right, (first row) Don West, Liz Sizeler, Glenn Kessler, and unidentified; (second row) Larry Sharrar, unidentified, Amy Spurill, and John Billingsley. (Courtesy of ATC.)

The Pennsylvania border provides one last bit of history before the trail leaves Maryland. To settle a dispute between followers of William Penn and descendants of George Calvert, surveyors Charles Mason and Jeremiah Dixon were commissioned in 1765 to firmly establish the boundary between the two colonies. To mark it, stones were placed every mile along the border. (Although the trail crosses the line, there is no stone there. This one, photographed by Dave Sherman, is on private property in close proximity to the AT.) Because the Mason-Dixon Line became the dividing point between slave-holding and free states, many believe that is why the South was called "Dixie." The name actually came from $10 bills printed by a Louisiana bank; much of the population in the state traced its ancestry to France and they referred to the money as *dix*, French for 10. The bills became so extensively distributed that the South became known as Dixie. The term became more widely used when a minstrel wrote and popularized the song *Dixie*. (Courtesy of ATC.)

Three

WESTERN PENNSYLVANIA

The mountains throughout Pennsylvania, which arch from the southwest to the northeast, are long, parallel ridgelines which, for the most part, stay well below 2,000 feet with little change in elevation. Initially, continuing along South Mountain that it followed into Maryland, the trail passes reminders of Pennsylvania's iron and steel industry. The Blue Ridge, the mountain range the AT has been following almost all of the way from Georgia, comes to an end as the trail encounters the Cumberland Valley. Crossing the valley for more than 10 miles, the AT traverses Blue and Cove Mountains before crossing the Susquehanna River at Duncannon and entering western Pennsylvania.

This current route in Pennsylvania, unlike the AT that has changed little in Maryland, is greatly altered from its original location. South of Caledonia State Park, a reroute of five to six miles moved the trail from near Raccoon Run onto the Rocky Mountain ridgeline, while small relocations have changed the route near Whiskey Spring and away from White Rocks. Major reroutes have also taken place from this point to the Susquehanna River.

Originally the trail followed roads in the more eastern part of the Cumberland Valley, coming within two miles of Mechanicsburg before rising onto Blue Mountain where it turned eastward to the Susquehanna River. Because there was no bridge across the river, in 1955 the trail was moved to roads a bit further west to facilitate a reroute over Cove and North Mountains, enabling the AT to cross the river at Duncannon. Today, thanks to acquisitions by the NPS and relocations during the 1980s and 1990s, the walk through the valley is a pleasant mix of a low ridge, open fields, and passage through the small village of Boiling Springs before joining the 1955 relocation to Duncannon.

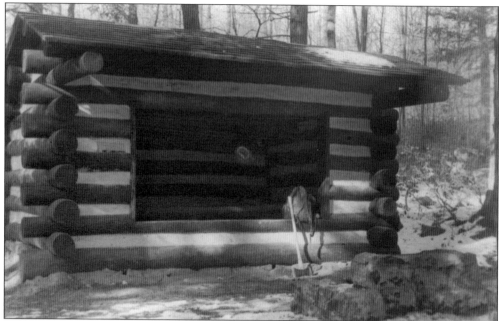

In 1936, the CCC completed construction of three shelters of creosoted chestnut logs and cement in the Mount Algo State Forest. The southernmost, the Mackie Run Shelter, could accommodate six people and was two miles north of the Mason-Dixon Line. It was removed in the 1980s because its accessibility from a nearby road made it susceptible to vandalism. (Courtesy of ATC.)

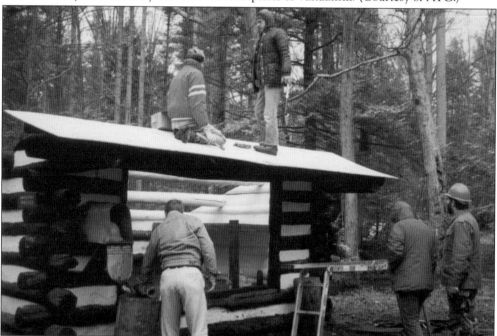

The Antietam Shelter was also built by the CCC in the 1930s and, with maintenance and a few minor modifications—such as replacing the original wire bunks with a wooden sleeping platform—it is still in use today. Volunteers of PATC have replaced the roof a number of times, as they were doing in this 1990 photograph by David Lepkowski. (Courtesy of PATC.)

In 1959, Boy Scouts try to build a dam to create a swimming hole by throwing rocks into Tumbling Run. The shelter is one of the three built by the CCC in Mount Algo State Forest in the 1930s. Hikers do not have to use the stream as a water source; they may obtain water from a spring a few yards beyond the shelter. (Courtesy of ATC.)

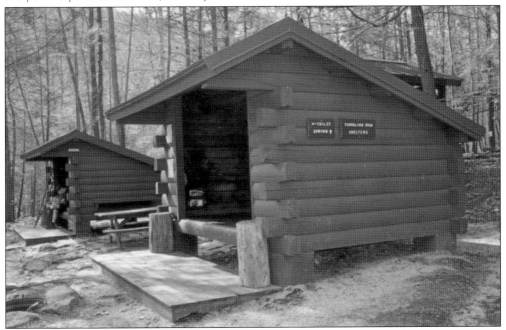

Following the precedent established by the CCC in the 1930s of building two shelters at other sites in Pennsylvania, two small shelters (accommodating four persons each) were built at Tumbling Run in the late 1980s. The use of factory-cut logs made construction easier than felling trees and shaping them on site. (Photograph by Laurie Potteiger; courtesy of ATC.)

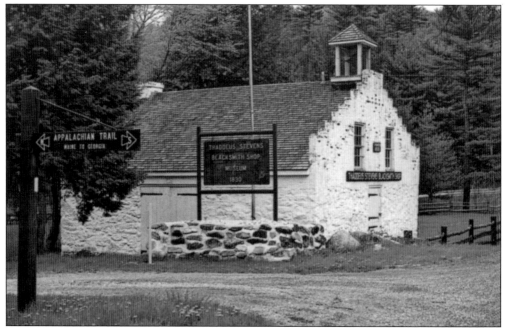

Before the reroute that took the AT onto the Rocky Mountain ridgeline in the late 1980s, it went by the Thaddeus Stevens Blacksmith Shop Museum at Caledonia State Park's entrance. Stevens began operating an iron furnace in the 1830s, but much of the facility was destroyed by Confederate troops in 1863. Stevens rebuilt in 1865 but passed away in 1868. (Courtesy of ATC.)

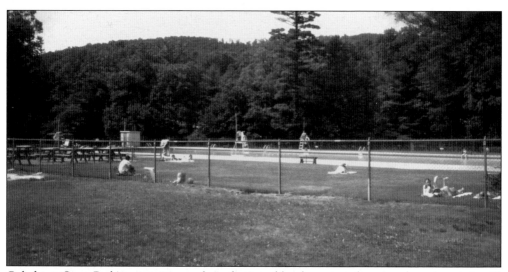

Caledonia State Park's swimming pool was bypassed by the same relocation, but, since it is still within two-tenths of a mile of the trail, its cool water and adjacent concessions continue to draw hikers. In 1927, the Pennsylvania Alpine Club reconstructed the old furnace stack in the park as a monument to the area's ironworks. (Courtesy of Leonard M. Adkins.)

In 1935, Benton MacKaye (photographed later in life) also helped found the Wilderness Society. That year he advised, "The Appalachian Trail . . . is not merely a footpath through the wilderness but a footpath of the wilderness." In 1971, he stated the trail "is a wilderness strip . . . a foot trail, and if there is a wheel on it at all, there is no point . . . People should get that through their heads." (Courtesy of ATC.)

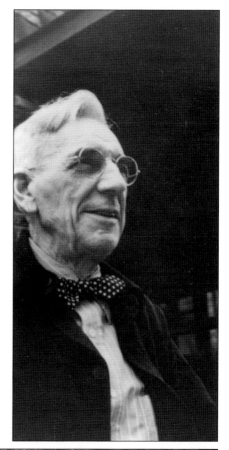

In 1959, the same group of Boy Scouts that were damming Tumbling Run hiked approximately 12 miles to stay at Quarry Gap Shelters. The 1930s CCC–built shelters are still in use, but volunteers have constructed a roof joining the two, creating a covered space that permits hikers to cook and socialize out of the weather. (Courtesy of ATC.)

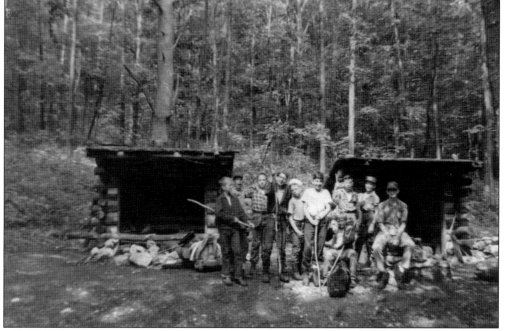

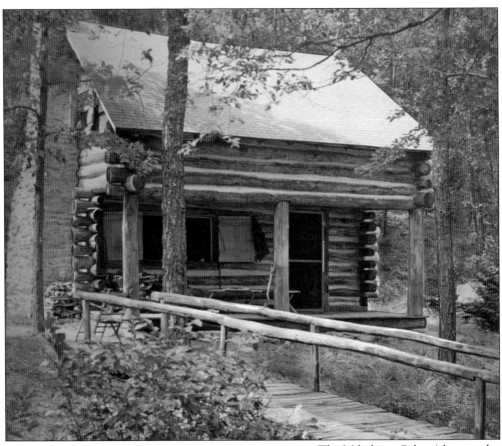

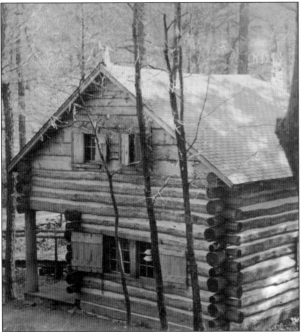

The Milesburn Cabin (above and left) is located 60 feet from the AT on the side of Big Flat in Michaux State Forest. ATC guidebooks say the cabin was constructed by the CCC in 1935, but other references claim that a ranger built it as his home without permission from authorities in 1930. First used by PATC in 1934, the cabin has been operated exclusively by the club since 1937 under a lease with the Pennsylvania Department of Environmental Resources. Cooking and living facilities are on the first floor, along with a fireplace and supplied kitchen and eating utensils. Sleeping accommodations are bunk beds with mattresses, blankets, and pillows. There is no electricity, so renters must bring some kind of portable lighting. (Both, courtesy of ATC.)

On April 29, 1934, Myron Avery joined PATC on a trip to clean Pine Grove Furnace Cabin. According to Jennette Speiden, "The debris not merely rags, bones and old iron, but such a miscellany of plaster, shingles and junk as would have dampened the ardor of any spectator. Crews organized . . . Myron Avery, a blurred figure wielding a broom among the dust clouds of the upper room, was recognizable only by his voice. Ken Boardman, scrubbing floors until the grain of the wood saw the light of day . . . Anna Michener built herself an enduring memorial in the iron plates she nailed to the kitchen ceiling. Otis Gates was everywhere, stacking wood, salvaging nails . . . plaintive voices were constantly calling, 'Harold, where shall I put this?' All afternoon the scrubbing of walls and floors, the burning of trash and the repairing of bunks went on! By sunset . . . the cabin was clean, the kitchen stove had proved its efficiency, the bunks for twenty people were ready for use and Otis Gates was screwing in place the framed rules for use of shelters." (Courtesy of PATC.)

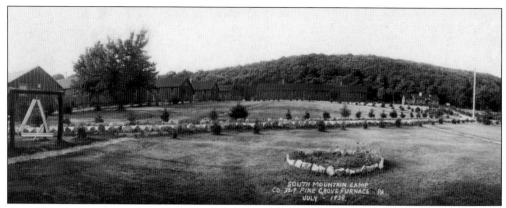

The AT goes by the site of the Pine Grove Furnace CCC Camp, where only building foundations, a fountain, and few other reminders of the camp's more than 40 structures remain. It was operated by the CCC from 1933 until 1942, when it was remodeled into a prisoner-of-war camp, holding both German and Japanese prisoners until World War II ended in 1945. (Courtesy of Lee Schaeffer.)

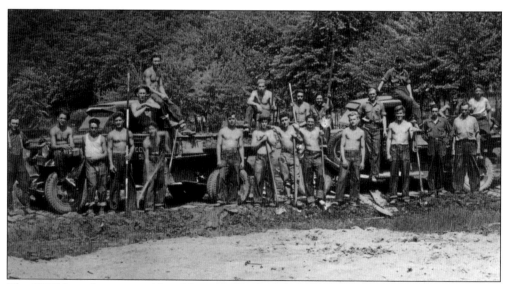

The CCC boys (most were 18 to 25 years of age) of the Pine Grove Furnace camp built much of the camp themselves, in addition to planting trees to reforest the area, constructing miles of roads, erecting telephone poles, and creating many of the facilities that are still in use in Pine Grove Furnace State Park. (Courtesy of Lee Schaeffer.)

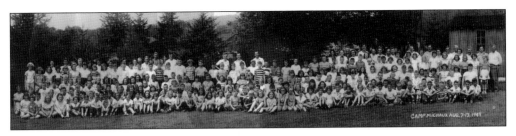

In 1947, the United Presbyterian Church and the United Church of Christ formed a corporation to operate the former CCC and prisoner-of-war camp as a children's summer camp. Known as Camp Michaux, it proved to be popular, as evidenced by the photograph (above) of the staff and attendees of just one of the one-week sessions. Attendees had a tight schedule that included religious training and physical and outdoors activities. A typical day started with wake-up and breakfast at 7:00 a.m., religious instructions and discussions before lunch, more workshops interspersed with swimming in the afternoon, vespers after dinner, and free time and planned activities in the evening. Attendees were expected to keep themselves and their facilities clean, as these young campers were doing (below) in the 1950s. (Both, courtesy of Lee Schaeffer.)

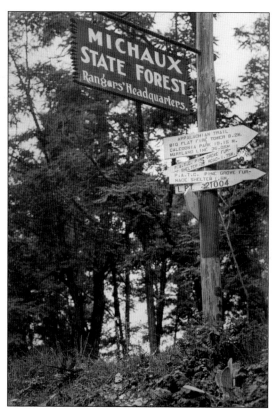

In the late 1930s and 1940s, the sign identifying Michaux State Forest Rangers Headquarters near Pine Grove Furnace State Park also had AT signs attached to it. Despite numerous relocations south of here, the distances identified on the signs are still fairly accurate. Because of vandalism and safety concerns, trail directional signs at road crossings are now often placed a few yards into the woods. (Courtesy of ATC.)

The AT goes by Ironmaster's Mansion as it enters Pine Grove Furnace State Park. Constructed by Peter Ege in 1829, the building is currently operated as a hostel. In the 1970s and 1980s, the few hostels along the trail were primarily church-sponsored. Today, there are dozens, most of which are commercially operated. (Photograph by Walter and Kim Harmon; courtesy of ATC.)

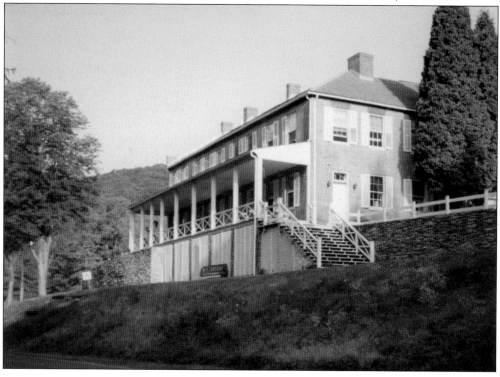

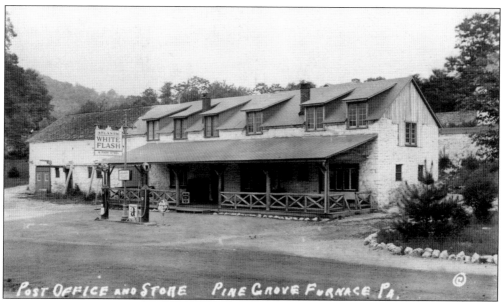

POST OFFICE and STORE PINE GROVE FURNACE PA.

Operated as a post office, store, and gas station when this postcard was published around 1920, this building was originally a Pine Grove Furnace stables, housing horses and mules. The animals brought lumber and charcoal to the furnace and hauled the finished iron product to market. It is believed that from about the mid-1800s, the Pine Grove Furnace complex was a part of the Underground Railroad. Since the late 1970s, the building, operating as the state park's general store, has had a somewhat less noble claim to fame as home of the infamous Half Gallon Club. Hikers join this dubious society by consuming a half gallon of ice cream each in just one sitting. (The author's half gallon was toasted almond, a flavor never eaten again.) (Above, courtesy of CCHS; below, courtesy of Leonard M. Adkins.)

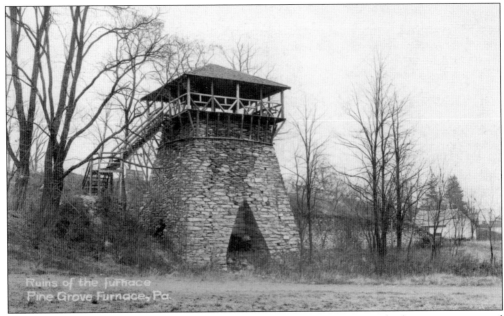

The only thing remaining of the furnace in Pine Grove Furnace is its stack, shown on a postcard as it appeared around 1910 with wooden steps and an observation platform. The AT did not go directly by the furnace as it does today but was originally routed on Hunter Run Road, about 100 yards from the furnace. (Courtesy of CCHS.)

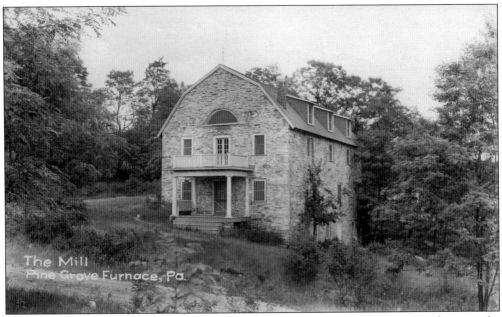

Pine Grove Furnace was a self-sufficient community that not only harvested the timber to make the charcoal and the iron, but also included company-owned farms whose grain was ground at the company-owned mill. The postcard shows the mill after it was converted into a residence sometime in the 1930s. It is now the home of the Appalachian Trail Museum. (Courtesy of CCHS.)

Larry Luxenberg thru-hiked in 1980. Jean Cashin, who started the tradition of taking photographs of those attempting to complete thru-hikes, took a Polaroid photograph of him at ATC headquarters on June 16. After interviewing close to 200 of the numerous 2,000-milers, Luxenberg authored *Walking the Appalachian Trail*, which, published in 1994, provides a broad overview of what is experienced when hiking the entire trail. (Courtesy of ATC.)

Larry Luxenberg, photographed at the grand opening of the Appalachian Trail Museum on June 5, 2010, was the driving force behind the museum. He is credited with originating the idea and was a founding member of the Appalachian Trail Museum Society in 2001. As with so much effort done for the AT, all Luxenberg did on behalf of the museum was on a volunteer basis. (Courtesy of Larry Luxenberg.)

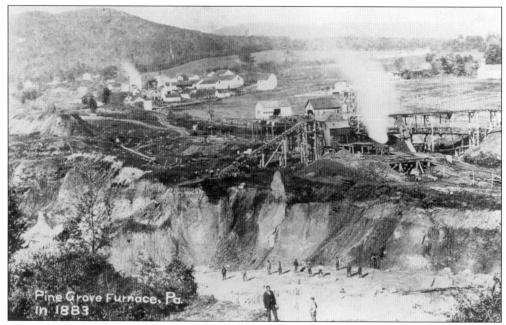

Pine Grove Furnace, Pa.
In 1883

The 1883 photograph (above) shows Pine Grove Furnace at its peak, producing 6,000 net tons of cast iron that year. The men below the cliffs are inside the quarry pit that is now Fuller Lake. If the route of the AT had existed at the time, it would have cut through the middle of facility, going by the furnace, underneath the ore tipple, and swinging around the pit. Pumps kept groundwater from filling the pit, but once operations ceased in 1895, the pit, which by that time was approximately 90 feet deep, filled with water, creating the lake. In 1913, Pennsylvania purchased the 17,000 acres of the ironworks and created Michaux State Forest and Pine Grove Furnace State Park. The postcard below shows swimmers enjoying the lake around 1930. (Both, courtesy of CCHS.)

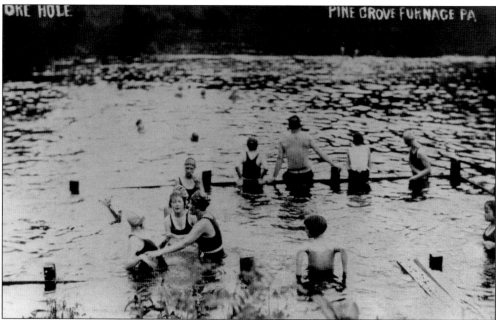

ORE HOLE PINE GROVE FURNACE PA

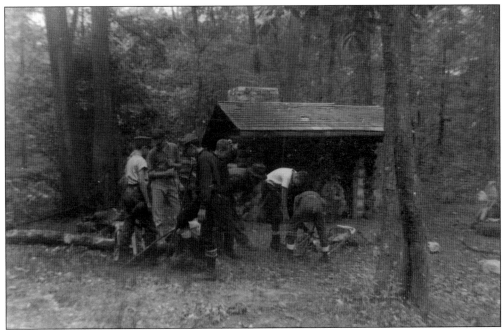

The same Boy Scouts that were photographed in 1959 at Tumbling Run (see page 53) and Quarry Gap (see page 56) continued their journey through Pennsylvania and stopped at Tagg Run shelters. The two shelters built in the 1930s were replaced by the James Fry Shelter in 1998. (Courtesy of ATC.)

Convenience stores near the AT are a welcome sight for hikers, and the Green Mountain Store on PA 34 has attracted them since the trail's early days. It was built as a tavern in 1930, complete with a dance floor and oval bar, a part of which has been preserved as the front counter where patrons now pay for their purchases. (Courtesy of Tom Mickey.)

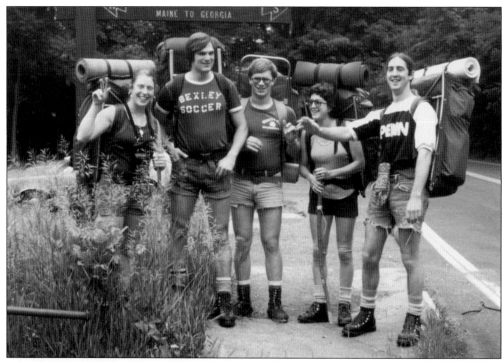

From left to right, Cindy Ross, John Mikulski, David Ross, Jo Ann Welsh, and Kevin Tasker were hiking on the AT in 1979, at a time when external frame packs, Ensolite sleeping pads, cotton T-shirts, cut-off cotton jeans, wool socks, and over-the-ankle mountaineering boots were the hiker uniform of the day. (Courtesy of Cindy Ross.)

Ted Sanderson continues the work of generations of AT volunteers by painting a blaze near Center Point Knob on June 6, 1990. In the trail's earliest days, an axe was used to notch a tree; later on the notch was covered with paint. Today, the paint is applied onto just a smooth spot created by scraping, thereby not damaging the tree. (Photograph by Mark Mullen; courtesy of ATC.)

In a twist on the traditional cartoon depicting the New Year's Baby leading the Old Year, Raymond Creekmore created this drawing to celebrate the dedication of the Center Point Knob plaque on December 8, 1935, with the young MCM, established in 1934, leading PATC, founded in 1927. Creekmore, chairman of MCM's Art Committee, also designed the plaque. (Courtesy of MSA.)

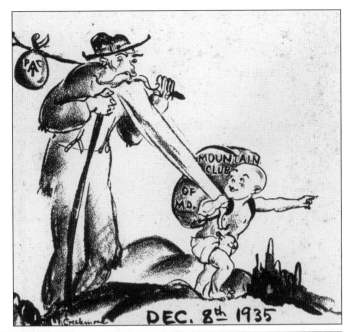

Thru-hiker resupply boxes are verification of the phrase "no man is an island," as no thru-hike is accomplished by one person alone. After making up these resupply boxes, filled with food, medication, money, and replacement clothing and equipment, thru-hikers leave them with family or friends to mail to the hiker via another vital thru-hiker link, the post office. (Courtesy of Cindy Ross.)

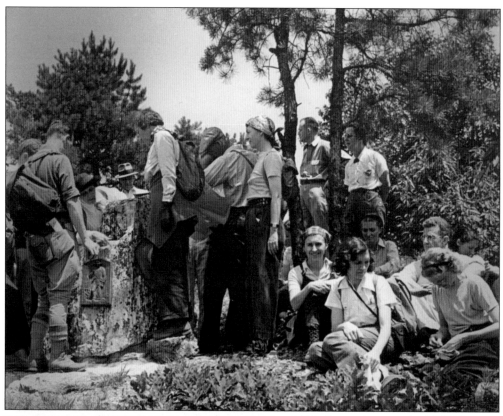

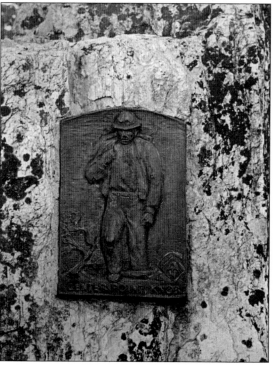

Abbie Rowe photographed PATC at Center Point Knob in the late 1930s or early 1940s (above). At the same time, Rowe photographed the plaque (left) that MCM members had bolted onto a boulder at the site on December 8, 1935. ATC chairman Myron Avery christened it with a bottle of "the purest spring water." The site was equidistant from the trail's southern terminus on Georgia's Mount Oglethorpe and northern terminus atop Mount Katahdin in Maine. Later, the plaque mysteriously disappeared, only to be found in a field after the turn of the 21st century. Having been returned to MCM, the club donated the plaque to the Appalachian Trail Museum. In 2012, the club also paid to have a replica of the plaque made and placed it on the same boulder. (Both, courtesy of ATC.)

The AT was 2,050 miles long when the Center Point Knob plaque was dedicated in 1935. Relocations have frequently changed the length of trail, and the trail's true center point has moved many times throughout the years. In 2014, the trail was more than 2,180 miles, and the center point was a short distance north of Pennsylvania's Pine Grove Furnace State Park. (Courtesy of ATC.)

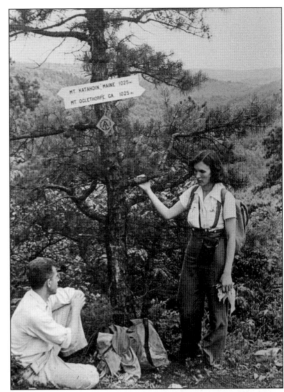

From Center Point Knob, the trail descends to cross Yellow Britches Creek and begin its traverse of the Cumberland Valley. Prior to this 1955 photograph, the trail followed roads close to Mechanicsburg, Pennsylvania; a relocation that year moved the AT onto roads a little farther west. At the time, the valley was primarily agricultural in nature, and most roads were dirt and lightly traveled. (Courtesy of MSA.)

Known as Halfway Sycamore because it, too, was once close to the midpoint of the trail, this was one of the few trees to provide cooling shade on the road walk through the Cumberland Valley. Other places have also been named to call attention to their having been the midpoint of the trail, such as Halfway Spring south of Pine Grove Furnace. (Courtesy of ATC.)

Cumberland Valley was still very agricultural as late as June 1978, when Jim Bradley photographed children riding bicycles on the roads that the AT followed near the intersection of Old Stone House and Lisburn Roads. The ridgeline in the distance is South Mountain, which the trail traverses through Maryland and the southern portion of Pennsylvania. (Courtesy of CCHS.)

Bonnie Shipe (left) became known as the "Ice Cream Lady" after she and her family moved into their Cumberland Valley home. Noticing that hikers crossed the valley during summer's heat, she provided ice cream cones and lemonade to help them on their way. The author (right) was the first person invited to spend the night in the family's home, in 1981. (Courtesy of Leonard M. Adkins.)

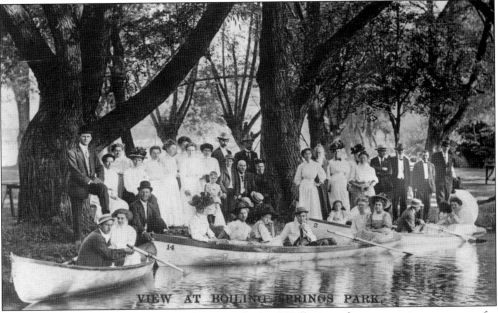

Increasing development and traffic along Cumberland Valley's roadways gave rise to concern for the trail's scenic quality and hiker safety. By 1990, a relocation had taken the AT off roads and into Boiling Springs, an 1800s resort destination. A park with a carousel, dance pavilion, and a miniature railroad was constructed in 1900 to attract visitors, and some posed for the photographer of this 1910s postcard. (Courtesy of CCHS.)

A boardinghouse lnown as Lakeside Inn (photographed around 1910) provided meals and lodging for the increased numbers of visitors after trolley lines were extended to Boiling Springs from Carlisle and Harrisburg, Pennsylvania, in 1885. "Boiling" does not refer to the water temperature but how the water roils to the surface from natural artesian well springs. Damming of the springs for water power formed Children's Lake. (Courtesy of CCHS.)

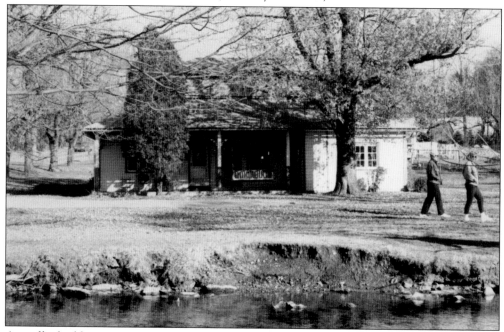

A smaller building was constructed on the same site at the north end of Children's Lake after the Lakeside Inn burned down in the early 1900s. Used for a number of businesses, it was refurbished and became ATC's Mid-Atlantic Regional Office in 1986. There are four such offices along the trail providing a presence on the local level. (Courtesy of ATC.)

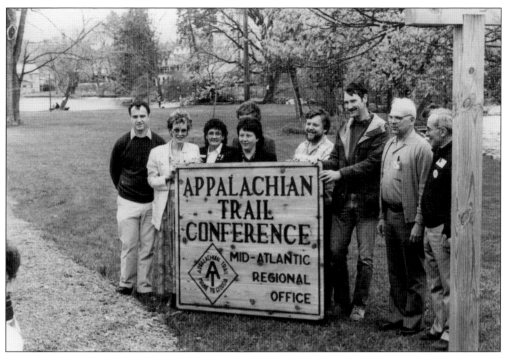

In 1986, ATC's regional office dedication in Boiling Springs was attended by several AT movers and shakers. From left to right are Anthony DeLuca, Carol Witzeman (CVATC officer), Rogene Schmiedel, Karen Lutz (ATC regional representative), Bill Hoppes (executive director of Trust for Appalachian Trail Lands), Craig Dunn (CVATC founding member), Ray Hunt (ATC chairman), and Charles Renaldi (chief of AT land acquisition office). The person standing in back is unidentified. (Courtesy of ATC.)

Although ATC's regional personnel spend days indoors working and in meetings, they often physically work on the AT. Mid-Atlantic regional director Karen Lutz helped repair damage from Hurricane Fran in 1996. She thru-hiked in 1978, has a degree in health; physical education, and recreation; directed a Youth Conservation Corps camp in Pennsylvania; and was hired by ATC in 1988. (Courtesy of ATC.)

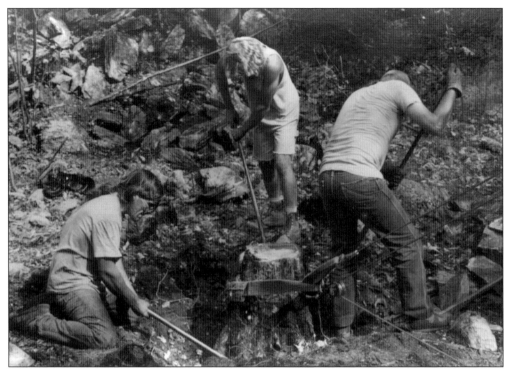

In the late 1900s, ATC established special volunteer crews, headed by trained trail bosses, to help local clubs accomplish tasks such as rock work, structure construction, and major relocations that are beyond the expertise of the average volunteer—such as the removal of a large stump from the trail route (above). Usually operating from late August to late October, the Mid-Atlantic crew is based at ATC's Scott Farm Trail Work Center in the Cumberland Valley and works on the trail from Rockfish Gap in Virginia to the New York-Connecticut border. Members of the crew volunteer to work for a five-day session, with many of them signing up for more than one session. (Other crews are located in multiple places along the trail, enabling them to help clubs along the AT's full length.) In 1996, Linda Martin photographed the Mid-Atlantic crew harvesting rocks (below) to be used in the construction of a new section of trail. (Both, courtesy of ATC.)

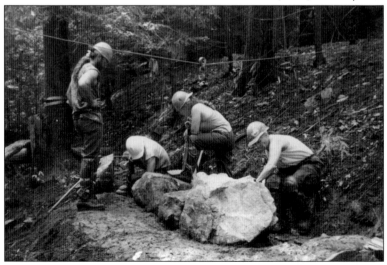

Gene Beenenga joined the Mid-Atlantic crew in 1990 to help construct a new bridge across a stream in the Cumberland Valley (right). Greg "Weathercarrot" Walter (below) exemplifies the dedication of thousands of hardworking AT volunteers. From 1993 to 2005, he volunteered on approximately 100 sessions with the Mid-Atlantic and Konnarock (works on the trail from Rockfish Gap, Virginia, to Springer Mountain, Georgia) crews, along with working with the Rocky Top crew in the Great Smokies and Long Trail Patrol in Vermont. He gained such expertise that he has done trail design and construction and stone work on private lands. Additionally, he has hiked the entire Long Trail, the AT four times, and the Pacific Crest Trail three times. Altogether, his long-distance hiking adds up to almost 21,000 miles. (Both, courtesy of ATC.)

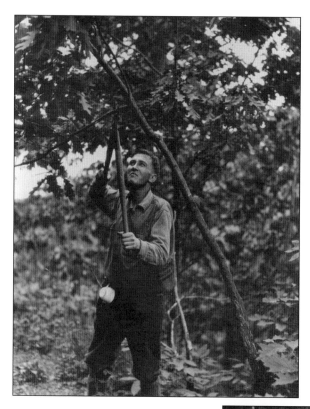

It is the major relocations and work projects on the AT that seem to get the most attention and publicity, but it is the everyday work of the volunteers that take up most of their time to keep the trail groomed and navigable. Harris Hollen is pictured here using loppers to keep brush and tree limbs from growing across the trail on June 16, 1929. (Courtesy of ATC.)

Going northward from Boiling Springs, the AT follows a low, wooded ridge through the valley, more or less on a route Earl Shaffer proposed in the 1950s. Members of the CVATC are shown continuing the perennial job of keeping vegetation from growing across the trail. The club is one of the newest of the trail-maintaining organizations, having been established in 1991. (Courtesy of CVATC.)

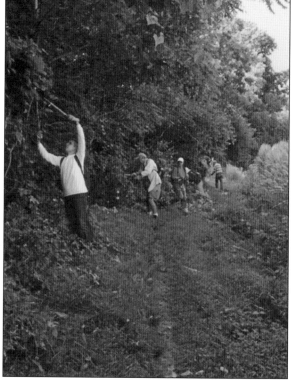

On April 28, 1990, Mark Mullen photographed the development that has taken place in the Cumberland Valley. In the foreground are CVATC volunteers planting trees to block the view of houses on Middlesex Road along the new route that opened that year. The relocation was controversial and created ill will toward the trail for years. Many valley residents protested the purchase of their lands for the trail. (Courtesy of ATC.)

ATC's headquarters staff also participate in work trips. In 1979, one year after being hired, David Startzel, with J. Botts looking on, was photographed by Rima N. Farmer as he did some rock work in an effort to control trail erosion. Increased trail usage has required more and more sophisticated trail construction techniques to keep it from deteriorating. (Courtesy of ATC.)

The AT comes close to several monuments, graves, and cemeteries along its full length, including the Chambers Cemetery surrounded by a wrought-iron fence within the Cumberland Valley. Some of the headstones are in disorder and broken apart, but death dates from the early 1800s are still visible. (Courtesy of ATC.)

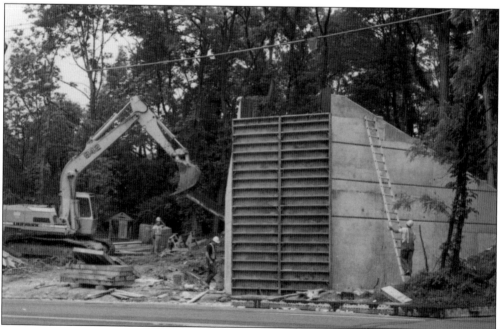

Hikers had to dash across the heavily used four-lane US 11 before the 1990 Cumberland Valley relocation. Concern for their safety brought about one of the trail's most elaborate footbridges (and obviously not a trail volunteer project). Mark Mullen photographed one of the pillars and ramps under construction in June 1990. (Courtesy of ATC.)

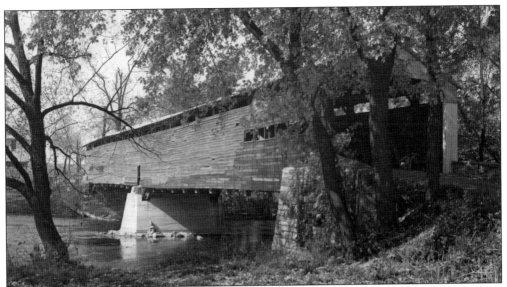

The AT has crossed Condoguinet Creek on a road bridge ever since the 1955 relocation. The covered Bernheisel Bridge was built in 1869, and it was replaced by a concrete and steel structure in 1959. The photograph was taken by C.H. Masland and Sons of Carlisle, Pennsylvania, in 1955. (Courtesy of CCHS.)

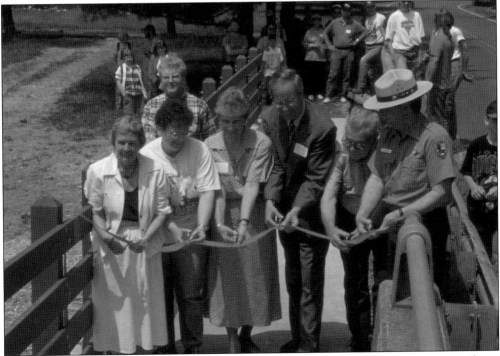

The concrete and steel bridge that replaced the covered Bernheisel Bridge was just two lanes wide, with scant space for hikers when two cars were crossing in opposite directions at the same time. Attending the grand opening of a newly constructed walkway in June 1997 are, from left to right, Nancy Besch, Janice Slaybaugh, Pat Vance, Mike Ryan, Dave Barr, and Bob Aray. (Courtesy of ATC.)

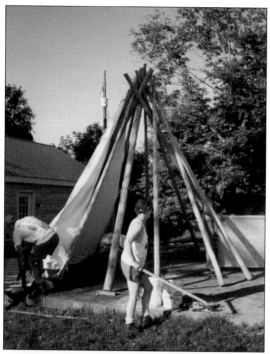

The Scott Farm, at the north end of the Bernheisel Bridge, is owned by the NPS. Known as the Trail Work Center, it the Mid-Atlantic work crew's base and the site of many functions, such as trail ridge runner training sessions. The teepees were constructed in the 1990s to provide additional lodging, but they were taken down a few years later. (Courtesy of ATC.)

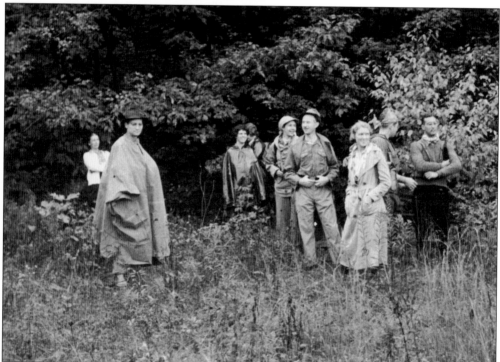

Members of MCM, maintainers of the trail north of the Cumberland Valley, took a hike to Doubling Gap on October 10, 1939. The site is not on the AT, but it is now connected to it via the 250-mile Tuscarora Trail through Virginia, West Virginia, Maryland, and central Pennsylvania. Constructed by PATC and KTA, the Tuscarora Trail was completed in the 1980s. (Courtesy of MSA.)

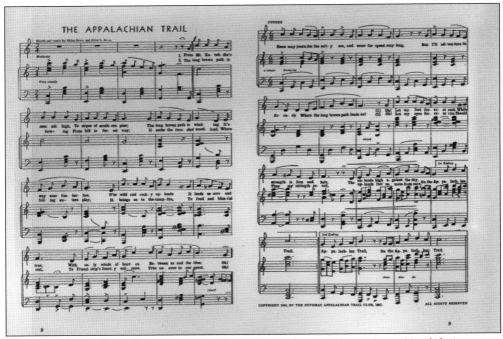

These are the words to the AT's unofficial song in the 1940s: "From Mount Katahdin's summit high, To slopes of southern pine; The long brown path is winding its way near timberline . . . Some may yearn for salty sea, and some to speed may long, but I'll adventure in Arcady where the long brown path leads on! Let my feet forever seek, while strength is firm and hale, the uplands high against the sky, on the Appalachian Trail." (Courtesy of PATC.)

Fred Ward, second president of MCM from 1938 to 1940, is in the center of the photograph taken by J. Henri Siegel. Lore says MCM was started when PATC members who lived in Baltimore, Maryland, grew tired of having to rise at 5:00 a.m. to attend that club's hikes, which originated in Washington, DC, and established a hiking club in their hometown. (Courtesy of MSA.)

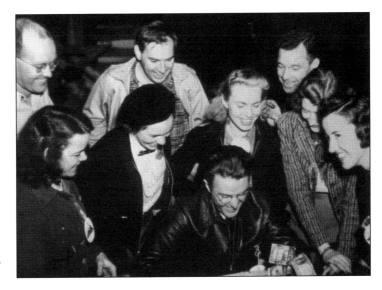

Four men who went on MCM's first hike in 1934 also participated in the club's 30th anniversary hike on October 14, 1954. From left to right are O.O. Heard (club president, 1942–1944), Jack Mowill (president, 1994–1996), Orville Crowder (founding president, 1934–1938), and Alex Kennedy (president, 1940–1942). Photographer W.R. Roessler was president from 1948 to 1950 and a founding member of KTA. (Courtesy of MSA.)

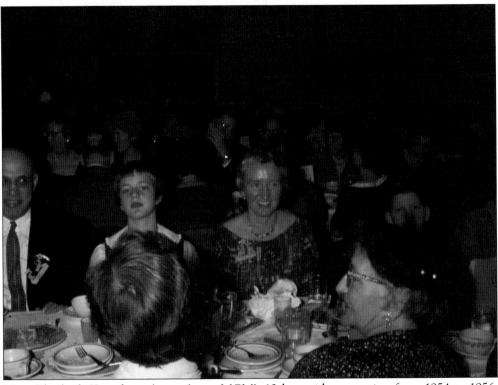

Mary Elizabeth Kamphaus (center) was MCM's 10th president, serving from 1954 to 1956. Photographed by J. Henri Siegal at the club's 35th anniversary celebration in 1959, she remained an active hiker into her 80s, ascending Mount Katahdin, Virginia's Old Rag, West Virginia's Seneca Rocks, and the Cotswolds in England. She died at 89 after being struck by a car. (Courtesy of MSA.)

Justrow W. Levin (left) and Sarah Cooper (right) take a break during MCM's 50th anniversary celebration hike in 1984. Levin organized the club's first all-day hiking trips in 1947, established the first outings devoted to orienteering, and served as club president from 1968 to 1970. The photograph is by Ted Sanderson, an active work trip organizer, shelters and privies chairperson, and president from 1988 to 1989. (Courtesy of MSA.)

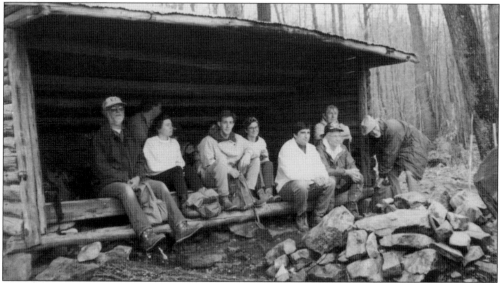

North of the Cumberland Valley, the AT ascends Blue Mountain to pass Darlington Shelter—the original shelter was constructed in the 1950s of native stone obtained from nearby and primarily built by Earl Shaffer, then ATC corresponding secretary; a newer shelter was constructed in 2005. In 1994, members of AHC take a break at Thelma Marks (early SATC officer) Memorial Shelter on Cove Mountain, six years before it was replaced by Cove Mountain Shelter. (Courtesy of AHC.)

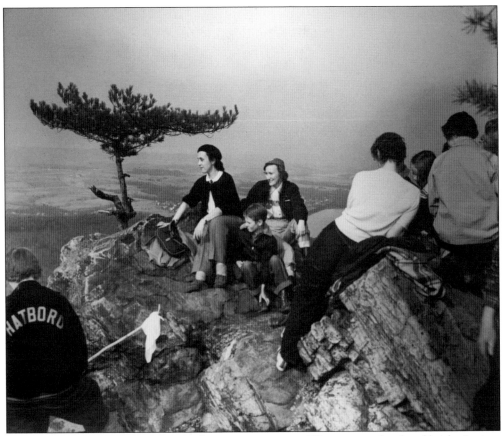

Hawk Rock on Cove Mountain provides a sweeping view of Duncannon bordered by the Juniata and Susquehanna Rivers and Sherman Creek. No date (thought to be 1950s–1960s) or caption was recorded for this photograph, but the rock has been a popular destination since settlers began arriving in the Susquehanna Valley. Unfortunately, due to ease of access, the rock is often covered by graffiti. (Courtesy of ATC.)

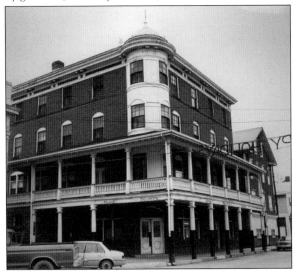

From Hawk Rock, the trail descends into Duncannon, home of the Doyle Hotel. Built around the turn of the 20th century on the site of the earlier 1800s National Hotel, the Doyle was a grand and well-appointed facility, a part of the Anheuser-Busch chain of hotels across the country. (Courtesy of ATC.)

The Doyle Hotel is not as luxurious as it once was. When Laurie Messick stayed there in 1982, many rooms had bare light bulbs and furnishing were decades old. Yet, it has been a hiker favorite since the trail was rerouted into Duncannon in 1955 because of reasonable rates, good food, and inexpensive draft beers. (Courtesy of Laurie Messick.)

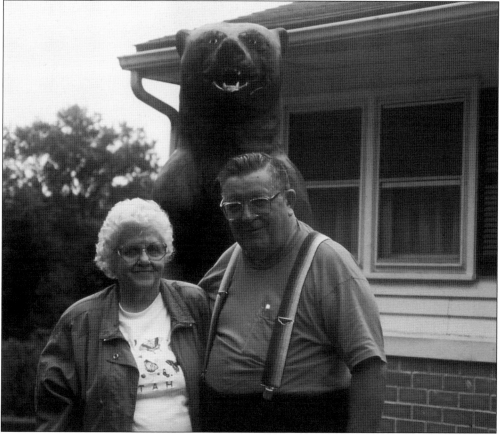

Elizabeth and William Fritz, known as Bethie and Bill, lived on North High Street when the AT (since relocated to North Market Street) went by their home and occasionally invited hikers to their house. Bill enjoyed taking them to nearby Amish Farms, and his sense of humor is evidenced by the large bear sculpture he placed on his front lawn. (Courtesy of Leonard M. Adkins.)

SATC honored Mary "Trailangelmary" Parry in 2012 for her services to hikers. Homeless in 2001, she lived a few months in a Duncannon campground, giving shuttle rides and food to hikers and becoming involved in the hiker community. Trail angels are to those who help hikers, asking very little, if anything, in return. Pictured here are, from left to right, Kim McKee, Parry, Barbara Van Horn, Paul Smith, and unidentified. (Courtesy of Sharon Shellenberger.)

The 1955 relocation through Duncannon finally gave the AT a way to cross the Susquehanna River. The original 1888 Clarks Ferry Bridge was a covered wooden structure. A concrete one replaced it in 1925, but its walkway was so narrow that tractor trailers' mirrors would almost touch pedestrians. The four-lane bridge that replaced it in 1986 has a wide sidewalk, making for safer passage. (Courtesy of ATC.)

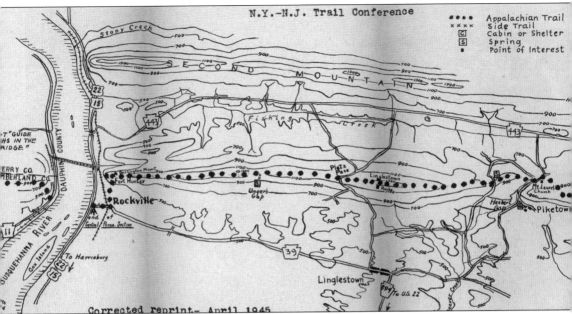

A 1945 map shows the AT before the 1955 relocation. From the Cumberland Valley's northern end, the trail turned eastward onto Blue Mountain, following what was (and is again) the route of the Darlington Trail, and came to a dead end at Overview on the Susquehanna River, with no way to cross the waterway. AT guidebooks at the time directed, "The connection between the western and eastern banks of the Susquehanna River, between Overview and the intersection of US 11 and Linglestown Road is not marked. To continue east on trail from Overview, take hourly bus from Marysville to Enola connecting with trolley line at Enola, and cross Susquehanna River to Harrisburg. Take Rockville Car (No. 5) north for app. 5 miles to crossing of hard-surfaced Linglestown Road; go east on Linglestown Road app. .25 mile and just beyond railroad underpass turn left onto dirt road. Follow trail markers to Fort Hunter."

There were several reasons that prompted Earl Shaffer and others to want to relocate the AT. A primary one was the dead end the trail came to on the Susquehanna River's western bank. Shaffer plotted and measured a proposed route, and to obtain manpower he helped establish SATC in April 1954. He is pictured at left with Murray Stevens (right). The 69-mile relocation (with route changes on both sides of the Susquehanna River) was completed on February 2, 1955. Shaffer and Stevens, ATC chairman at the time, had big smiles when attending the relocation's formal dedication on the Clarks Ferry Bridge in March 1955 (below). It was such a big deal that traffic was halted as they and Daniel Hoch (who introduced 1945 legislation in Congress to create a national trails system) shared the ribbon-cutting ceremony. (Both, courtesy of ATC.)

Four

EASTERN PENNSYLVANIA

Many AT relocations have occurred in eastern Pennsylvania. In addition to the problem of getting across the Susquehanna River described in chapter 3, the Fort Indiantown Gap Military Reservation closed the AT during World War II and continued to close it during prime hiking season after the war. The solution, part of the 1955 relocation that also took place west of the river, was to move the trail off Blue Mountain (out of Indiantown, Manada, and Heckert Gaps) and onto Peter, Stony, and Second Mountains before coming into Swatara Gap. (As was the case in several places in the early days of the trail, there had been two simultaneous AT routes coming into Swatara Gap before the relocation.) East of Swatara Gap, Pulpit Rock and the Pinnacle were originally reached by side trails, and the descent into Eckville was on Windsor Furnace Road. There have also been minor changes as the trail continued to Delaware Water Gap.

The current route of the AT, after crossing the Susquehanna River at Duncannon, rises onto Peters Mountain, enters Saint Anthony's Wilderness—the largest tract in southeastern Pennsylvania without a road—and passes crumbling foundations marking the site of Yellow Springs Village, a long-abandoned mining community. Disturbed land, an old railroad grade, and a family cemetery are all that remain of Rausch Gap Village.

With little change in elevation, except to cross the Schuylkill River at Port Clinton and the Lehigh River near Palmerton, the AT follows Blue Mountain to Wind Gap. It is here that the famous rocks of Pennsylvania that hikers tell about in horrifying detail become so abundant they keep hikers from putting their feet flat on the ground. The AT crosses over to Kittatiny Mountain and descends more than 1,000 feet to cross the Delaware River and enter New Jersey.

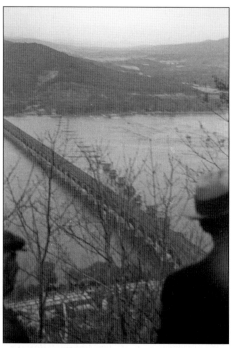

Members of BMECC look onto the Susquehanna River prior to the 1955 relocation. Guidebooks of the time admonished, "The Pennsylvania Railroad bridge crosses the river app. 1 mile north of Overview. It is used locally although there is no footbridge; persons crossing the bridge are trespassers and subject to arrest for violation of the law. This bridge is no part of the Appalachian Trail." (Courtesy of BMECC.)

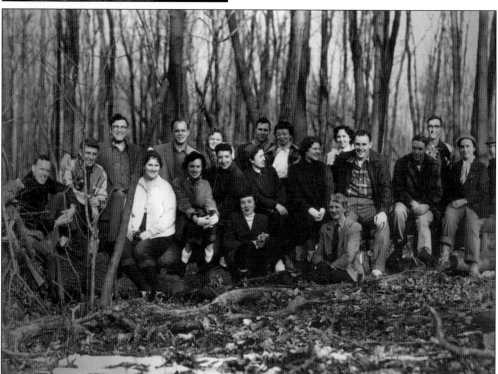

Approximately 350 people attended the celebration of the 1955 relocation that was held at the Harrisburg Civic Center on Saturday, March 19. The official ribbon-cutting ceremony on the Clarks Ferry Bridge took place the next day, followed by this group taking a hike to Hawk Rock. (Courtesy of Thelma Marks and ATC.)

In 1932, the Back to Nature Club of York County was formed under the auspices of the county bureau of recreation during the Great Depression to provide a way for people to socialize and enjoy inexpensive recreational opportunities. Because there was already a Back to Nature Club in the Philadelphia area, the name was changed to the York Hiking Club in 1939. In addition to maintaining the AT, the club also works on the southern York County section of the Mason-Dixon Trail, a 196-mile pathway that connects with the AT at Whiskey Springs and heads eastward to terminate at it junction with the Brandywine Trail at Chadds Ford, Pennsylvania. Three of the club's members, Mary Elizabeth Nieman (left), Ross Rigdon, and Ada Gladfelter, participated in a club hike in 1936. (Courtesy of York Hiking Club.)

From left to right are Sylvia Weckesser, Maurie Wuerthner, and Ken Newcombe, also participating in a 1936 outing with YHC. Weckesser and Newcombe met while attending club activities and later married. In fact, throughout the AT's history, many marriages have taken place as a result of people having met during a hike, work trip, or one of the maintaining clubs' social events. (Courtesy of YHC.)

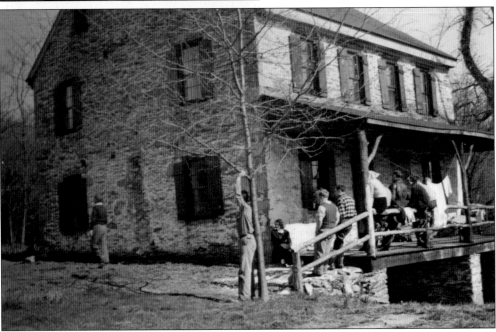

In 1948, YHC obtained a lease for the John Paul Jones House (pictured here in 1940), a two-story stone farm home constructed in the early 1800s on the banks of the Susquehanna River. Many of the AT maintaining clubs own or rent cabins in the woods as a place for social events, a base of operations for work trips, and a place for members to individually use. (Courtesy of YHC.)

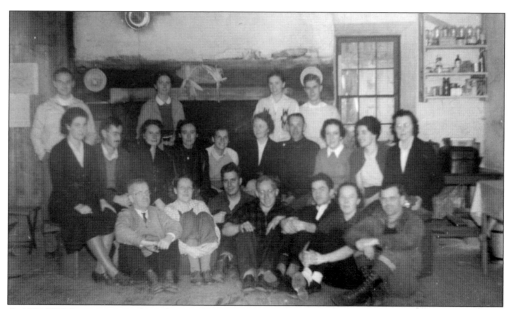

A 1938 YHC meeting at the John Paul Jones House was attended by, from left to right, (first row) Bill Palmer, Maurie Wuerthner, George Kain, Dick Hackaman, Jim Williams, Frances White, and Paul Bowers; (second row) Mary Bortner, Paul Gundrum, Ada Gladfelter, Polly Thorne, Mary Neiman, Alta Bell, Johnny Williams, Margaret Lewis, unidentified, and Margaret Forrey; (third row) two unidentified individuals, Emily Kain, and Bill Kain. (Courtesy of YHC.)

The caption William Roessler gave his photograph taken August 6, 1939, was, "At John Paul Jones of Susquehanna. The camera spots a pair of choice blondes—Vivian Heller and Sally Ruth." Roessler was a founding member of MCM, club president from 1948 to 1950, secretary from the 1950s to 1970s, and known as "Mr. Photographer." (Courtesy of MSA.)

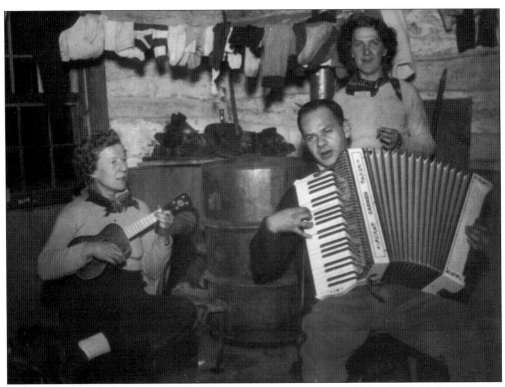

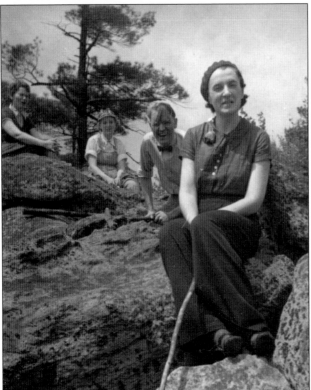

Rita Baker (left), Phil Gladfelter (center), and Peggy McGee (right) were photographed by Lawrence Brons providing evening entertainment for an outing in c. 1940. Brons gave it the caption, "It's the Same the Whole World Over," presumably for the song that was being performed. It is a British folk song about a rich man taking advantage of a poor girl, and some versions can be quite bawdy. (Courtesy of MSA.)

Just because they work on the Appalachian Trail, most maintaining clubs do not limit their outings to the AT. From left to right, YHC members Ada Gladfelter, Helen Baird, Emil Neubauer, and Dorothy Neubauer hike to Devil's Den in the Gettysburg National Military Park in the early 1940s. (Courtesy of YHC.)

One of YHC's earliest members, Richard Heckaman, joined in the 1930s and organized what he called "gypsy hikes." He would announce an outing but not reveal its destination. Harriet Sadler and Paul Gundrum dressed so as to be in the spirit of the adventure. (Courtesy of YHC.)

In a posed photograph on June 11, 1950, YHC volunteers Earl Shaffer (left), Madeline Fleming (center), and Leonard Kable (right) demonstrate tools often used to maintain the AT—a weed trimmer, lopping shears, and paint brush. Shaffer became active in the club after his historic 1948 thru-hike and served as president for a year before helping to found SATC. (Courtesy of YHC.)

Madeline Fleming, also a KTA founding member, was still active with YHC nearly two decades after the previous photograph was taken; here she was taking a break during an AT hike in May 1969. The MacKaye family papers, preserved at the Rauner Special Collection Library in Hanover, New Hampshire, reveal Fleming exchanged correspondence with Benton MacKaye in 1961. (Courtesy of YHC.)

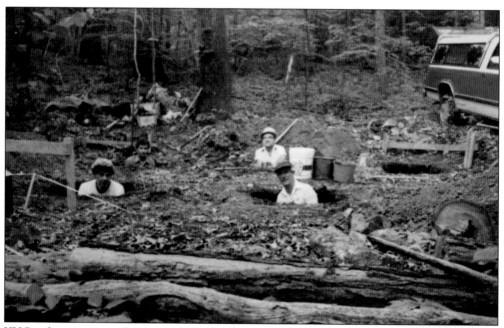

YHC volunteers were deep into the holes they were digging for the foundation of the Clarks Ferry Shelter on June 13, 1987. From left to right are (first row) George (Sam) Schneider and Carl Reachard; (second row) John Seville and David Hibbs. Seville was club president in the mid-1980s and has been on house and activities committees for more than two decades. (Courtesy of YHC.)

KTA was formed to help Pennsylvania's AT maintaining clubs coordinate their efforts. Its members now oversee more than 1,000 miles of Pennsylvania pathways. It was a who's who of AT luminaries of the mid-1900s that attended the first meeting in 1956. Above are, from left to right, (first row) Charles Hazelhurst; (second row) Elmer Bolla, Ruth Bolla, and Mel Brinton Jr.; (third row) Anna Michner (partially hidden), two unidentified, and Moe Fleming; (fourth row) Mary Kamphaus, Anna Kinter (partially hidden), and D. Owens; (fifth row) Charles Clark, Gil Owens, and Woody Kennedy. In the photograph below are, from left to right, (first row) William R. Roessler, Ernie Thorrne, Larry Gage, and Mel Brinton; (second row) unidentified and Earl Shaffer (partially hidden); (third row) Dick Kimmel and John Frisker. (Both, courtesy of KTA.)

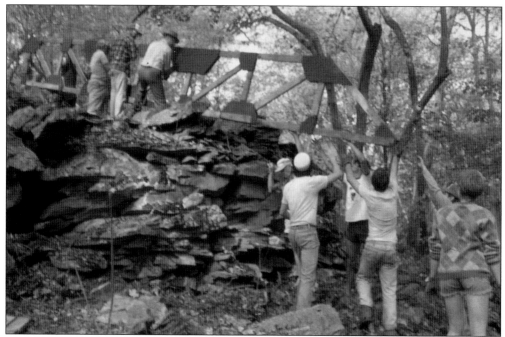

Trail volunteers must be prepared to perform a wide variety of tasks, and sometimes they have no idea what they will be asked to do. On November 5, 1986, members of KTA unloaded and carried the trusses for a footbridge across a swampy area in eastern Pennsylvania. (Courtesy of KTA.)

The stone arch bridge in St. Anthony's Wilderness is believed to be the oldest bridge the AT crosses on its entire length. It was constructed over Rausch Creek around 1850 as part of the railroad system that carried coal mined in the area to market. The photograph was taken in April 1978 by Henry Knauber of Wiconsico, Pennsylvania. (Courtesy of ATC.)

BMECC was formed in 1916, five years before Benton MacKaye's 1921 AT article. In October 1926, Prof. Eugene Bingham of Easton's Lafayette College challenged club members to create a 100-mile Skyline Trail to be a part of the AT. In less than four years, the club completed the 102 miles from the Lehigh River to the Susquehanna River. The 1936 photograph (right) was taken in Manada Gap (no longer on the trail) during the dedication of the Runkle brothers monument (they worked on much of the route). Below, Nicholas Philipson photographed, from left to right, Dr. S. Banks Taylor, Daniel Hoch (second club president), Dr. H.F. Rentschler (first secretary and driving force behind the club's establishment), and unidentified on the first hike from Pocahontas Spring to Port Clinton. (Both, courtesy of BMECC.)

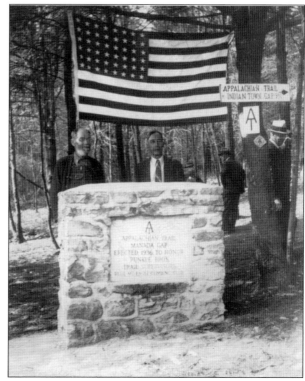

Pennsylvania state representative Daniel K. Hoch was a founding member of BMECC and attended the hike that marked the first portion of the AT in Pennsylvania. He is pictured here at the dedication of the plaque in his honor at Pilger Ruh in 1935. Moravian missionary Count Zindendorf named Pilger Ruh (Pilgrim's Rest) in 1742 because the spring never failed to flow. (Courtesy of BMECC.)

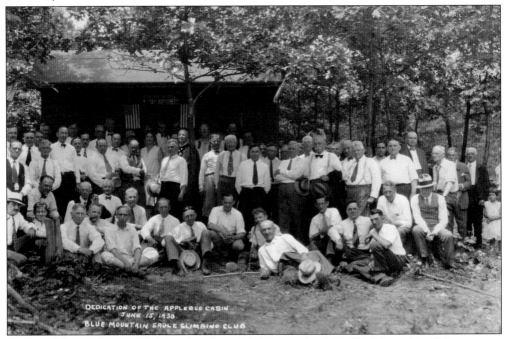

The Applebee Cabin was dedicated on June 15, 1930, on land BMECC leased for "12 acorns to be paid each October." The club's Wilderness Park Association later purchased the tract, but the shelter was removed in 1971 due to vandalism. Note that all dedication attendees, except two women and a small girl, are male. The club did not open membership to women until several years later. (Courtesy of BMECC.)

In 1930, BMECC built the Hertlein Cabin in Shubert's Gap in memory of William Hertlein. Hertlein's widow provided the funds for the cabin and also purchased the land on which it was constructed. The cabin was greatly abused due to its easy access from a nearby state road, and it was removed in 1971. The location is now a campsite. (Courtesy of BMECC.)

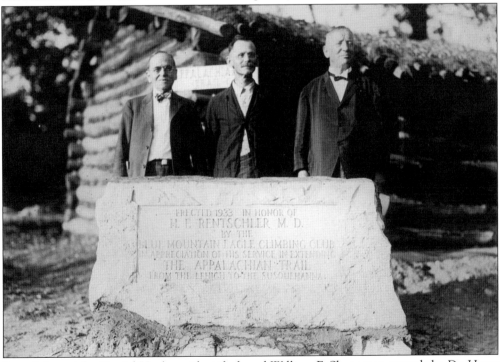

From left to right, Daniel Hoch, unidentified, and William F. Shanaman attend the Dr. Harry F. Rentschler shelter and monument dedication on June 25, 1933. In 1916, Rentschler led the hike to the eagle's nest that gave BMECC its name and is credited as being the club's founder. Shanaman went on that hike and was elected BMECC's first president. The shelter was removed in the 1960s; the monument remains. (Courtesy of BMECC.)

The trail in its earlier days often used many miles of roads—sometimes for expediency and sometimes out of necessity. In November 1975, AHC members Rosemary Croxton (left) and Esther Upton (right) walked the 6.5 miles of the AT on a Pennsylvania state game land dirt road from PA 183 to Neys Shelter. AHC was formed in 1931 with annual dues of $1. (Courtesy of AHC.)

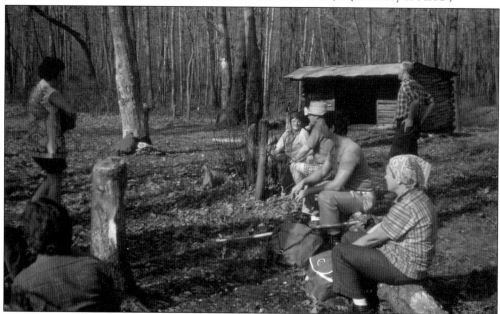

AHC members take a break at Neys Shelter during the same November 1975 hike. Standing at left is Esther Upton; standing at right is Dick Leach. Sitting at the back of the log is Alfred Wiemann, and Harold Croxton, who became a 2,000-miler in 1976, is next to him. Others are unidentified. The shelter (no longer in existence) was constructed in the 1930s by BMECC near the former Neys Tavern site. (Courtesy of AHC.)

Usually the materials to build a shelter must be carried in (sometimes for miles) by volunteers to the site. In 1988, the National Guard used a CH-54 helicopter to transport the (75 percent completed) Eagles Nest Shelter as a training exercise. BMECC members had spent the previous months putting the shelter together and completed the job once it had been lowered onto its permanent site. (Courtesy of ATC.)

The photograph's caption is "Snapped Nov. 6th, 1927 at Windsor Furnace on the Appalachian Trail climb to Devils Pulpit where we were greeted with a blinding genuine New England snow squall. This group in the picture represent the matchless inimitable big four in the Skyline Trail development. Left to right, Doctor Harry F. Rentschler, Raymond H. Torry, William F. Shanaman, and Judge Arthur Perkins. Compliments of Shanaman." (Courtesy of ATC.)

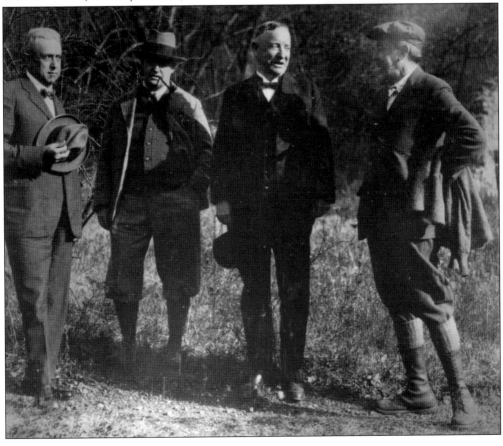

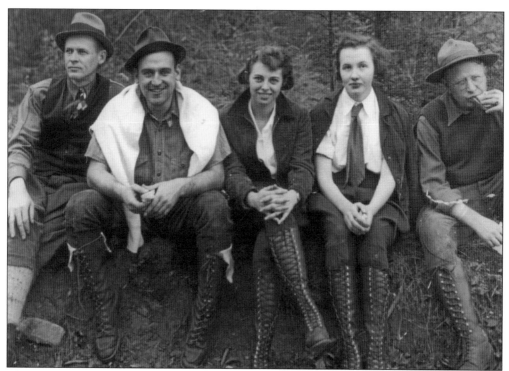

The inscription on the back of this photograph says these unidentified AHC hikers are "resting along the roadside to Eckville, 1935. Photograph by Jacob Santa Maria." Most are wearing the hiker's uniform of the day—over-the-calf boots to protect from snake bites and briers and jodhpurs made of wool that were able to provide warmth even when wet. (Courtesy of AHC.)

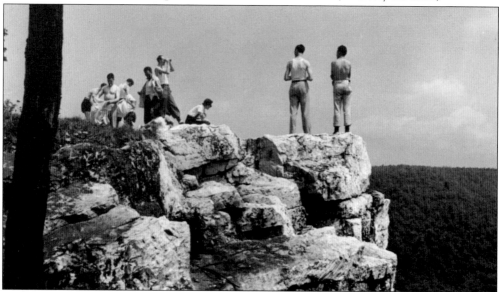

WTC took a hike to Pulpit Rock in 1940 when it was reached by a side trail. The 1970 AT guidebook for Pennsylvania says, "In order to give the hiker a much more scenic route and also to help protect the area under the National Trails System Act the AT is here rerouted (in 1969) by way of Pulpit Rock and the Pinnacle." (Courtesy of WTC.)

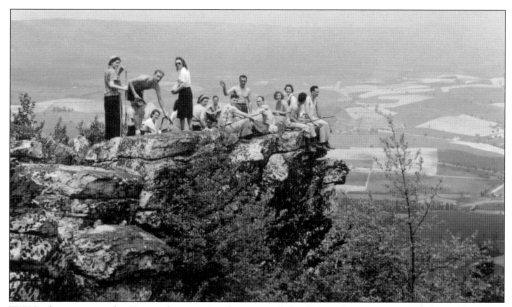

WTC also went to the Pinnacle to enjoy the view of the Pennsylvania countryside on the same hike taken to Pulpit Rock in 1940. The vista has changed little since then, and the 1970 AT guidebook said, "This is a MUST see." Current guidebooks call the Pinnacle "the most spectacular viewpoint on the trail in Pennsylvania." (Courtesy of WTC.)

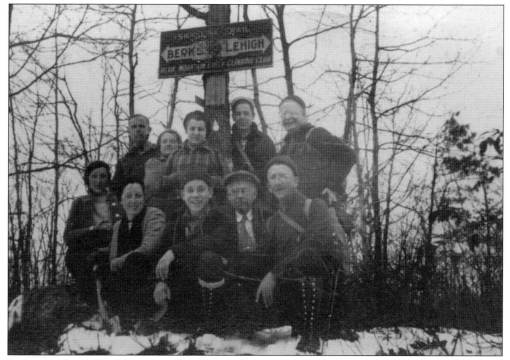

Early members of AHC pose at Tri-County Corner, where the Blue Mountain Eagle Climbing Club, led by Dr. Harry Rentschler, placed the first blaze, and construction of the AT (originally called the Skyline Trail in this area) was started in Pennsylvania on November 21, 1926. (Courtesy of AHC.)

As have countless volunteers, David Crosby has spent decades working on the AT. He became BMECC's shelters chairman in 1984, and he led volunteers in the Eagles Nest Shelter construction in 1988. He has continued to volunteer even after a tracheostomy to treat vocal cord cancer left a hole in his neck in 2007. Crosby is pictured here working on the new Rausch Gap Shelter in 2012. (Courtesy of Brain Swisher.)

For 10 Sundays during April, May, and June 1935, a total of 29 members of AHC worked on the Allentown Hiking Club Shelter. After hiking to the site and cutting down 75 trees, the volunteers trimmed and stacked the trunks to form the walls of the three-sided, Adirondack-style shelter, completing it in two more Sundays after putting on the roof. (Courtesy of AHC.)

The Allentown Hiking Club Shelter (above) is pictured here soon after its completion in 1935. Most AT shelters follow, to some degree, the same simple three-sided construction as this one and are designed to sleep six to eight people. Many shelters originally had fireplaces constructed next to them, but over the years the mortar between the stones dried out and the structures crumbled. Today, most shelters have primitive rock fire rings or manufactured iron fire grates. The photograph of Robert Reinhard (below), a 2,000-miler, is a good illustration of how the AT volunteers' work is never done. Even though the AHC shelter was completed in 1935, its walls needed to be rechinked every few years, a job Reinhard performed in 1975. (Both, courtesy of AHC.)

The Wiemann family is like many that become a part of the AT community—their love of the trail is passed to succeeding generations. Barbara Wiemann (who met her husband, Alfred, on an AHC hike in 1974) took her 1.5-year-old son Jeff on his first backpacking trip to Smith Gap in August 1981. Their daughter Elizabeth visited the AHC shelter at only two months old. (Courtesy of Barbara Wiemann.)

Cindy Ross and Todd Gladfelter met while becoming 2,000-milers in the late 1970s. The journey sparked further adventures, and they completed the Pacific Crest Trail and then the Continental Divide Trail with their children Bryce (front) and Sierra when the children were less than five years old. As a family (pictured here in the 1980s), they have hiked, paddled, and cycled in Asia, Africa, South America, and Europe. (Courtesy of Cindy Ross.)

The new Allentown Hiking Club Shelter, built in 1996, was photographed by Elizabeth Wiemann in 1997 and featured in an Appalachian Trail calendar. Note that the new shelter is constructed of machined logs, precluding the need for chinking. (Courtesy of AHC.)

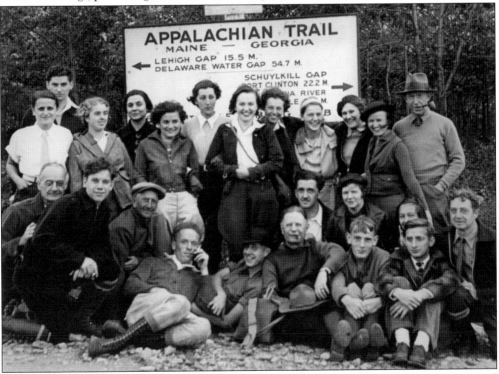

AT maintaining clubs do not just work or walk on the trail; most sponsor events take on social aspects such as AHC's October 11, 1936, outing. It was not only a hike to Blue Ridge Summit, but also included dinner at the restaurant located in the gap. (Photograph by Jacob Santa Maria; courtesy of AHC.)

It is believed this 1936 photograph was also taken by Jacob Santa Maria. The hikers and the place are not identified. Spyglasses, also known as monoculars, were more popular at the time than binoculars. One reason was that the spyglasses could collapse, making them easier to carry in a pack than binoculars. (Courtesy of AHC.)

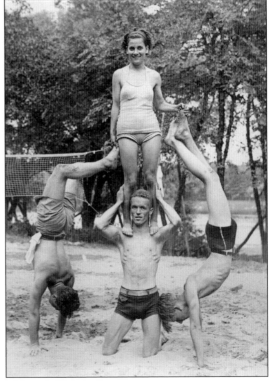

AHC would often combine summertime hikes with swimming, as seen here during a 1930s outing to Hickory Run (about 50 miles north of Allentown) before it became a state park in 1945. Another favorite destination in the warmer months was Ricketts Glen, northwest of Wilkes-Barre. It too became a state park in the 1940s. (Courtesy of AHC.)

James Unkle displayed his sense of humor during a holiday outing to Hickory Run State Park on July 4, 1946. He and his wife, Marion, were made honorary AHC members in 1965 for their longtime dedication to the organization. James passed away in 1971 and Marion in 1987. (Courtesy of AHC.)

Pictured here in 1968, Jane Beck and Merritt Zimmerman met during an AHC hike and later married. From 1955 to 1975, Merritt, at one time or another, held each of the four main officers' positions on the club's board—president, vice president, secretary, and treasurer. He was also KTA president in the 1960s and 1970s and helped establish the Tuscarora Trail. (Courtesy of AHC.)

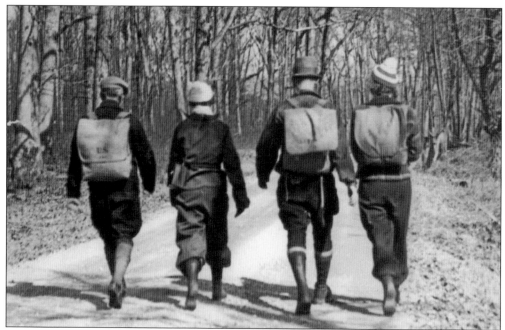

AHC historian Barbara Wiemann believes this February 28, 1937, photograph was also taken by Jacob Santa Maria. The location is given only as Carbon County, whose border with Lehigh County the AT follows. Early trail hikers, including Earl Shaffer, used soft-sided rucksacks, as aluminum external frame backpacks were not manufactured until the 1950s. (Courtesy of AHC.)

A unidentified BMECC volunteer works on the deacon's seat during the construction of the George W. Outerbridge Shelter in April 1964. The term came from logging camps where such a bench in front of bunkhouses was used by a circuit preacher as his pulpit. It was also a camp's gathering place where lumbermen met to socialize and discuss their work. (Courtesy of ATC.)

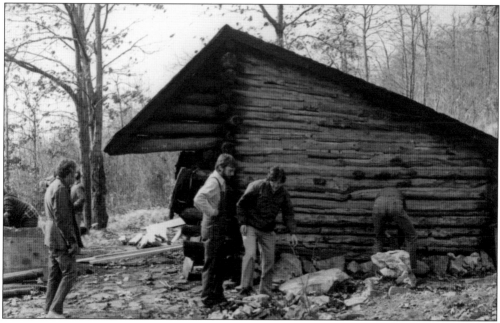

There were plans to abandon the George W. Outerbridge Shelter in the late 1970s, but AHC took on the responsibility and installed a floor, replaced the roof, rebuilt the fire ring, and generally rehabilitated the area. From left to right are AHC volunteers Jim Murray, Sam Carlson (club president, 1983–1985), and Barbara Wiemann, who has held many volunteer positions and received ATC's 25 Years of Service Award in 2001. (Courtesy of AHC.)

The AT's protected corridor is home to thousands of plants and animals, which, unfortunately, attract poachers. Some dig endangered plants, others harvest plants for the commercial market, and some take organs and other body parts of animals for the black market. Officials captured this black bear's killer in the 1960s. He had hoped to sell its gall bladder in Asia, where it was used to treat illnesses. (Courtesy of DWGNRA.)

The AT has been the scene of many airplane crashes, the most famous being the one that killed World War II hero Audie Murphy in central Virginia. In the 1970s, AHC member Earl Raub obtained permission from the insurance companies to remove several wrecked planes from the trail. He used a hacksaw (left) to cut one of the downed aircrafts into manageable pieces to be hauled away. Helping to clean up one of those sites (below) in 1979 are, from left to right, AHC volunteers Harold Croxton (a 2,000-miler, AHC trails chairman in the 1970s and 1980s, and KTA's statewide AT monitor corridor in the 1980s), unidentified, and Alfred Wiemann. (Both, courtesy of AHC.)

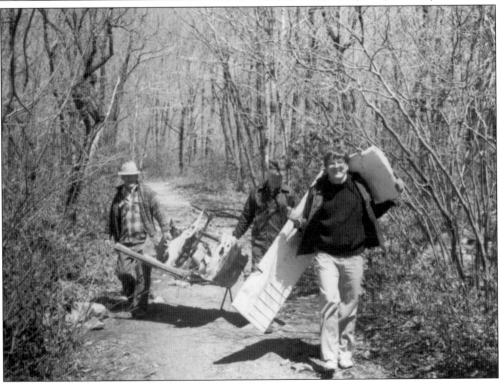

The New Jersey Zinc Company (above) operated smelting facilities near Lehigh Gap for more than 80 years. Without pollution controls, the plants filled the air with toxins that denuded Blue Mountain, where the AT had been located in the 1920s and 1930s. Even lichens, bacteria, and fungi could not exist. Erosion followed, and by the 1970s, all that remained were rocks and subsoil. The Environmental Protection Agency closed the factories in 1980 and soon declared the area a Superfund site. Initial restoration efforts by the agency had little effect. Grass and tree plantings and other remediation efforts by the Lehigh Gap Nature Center, which purchased some of the mountain, have been more successful, but recovery is slow, as evidenced by the 2013 photograph below. (Both, courtesy of ATC.)

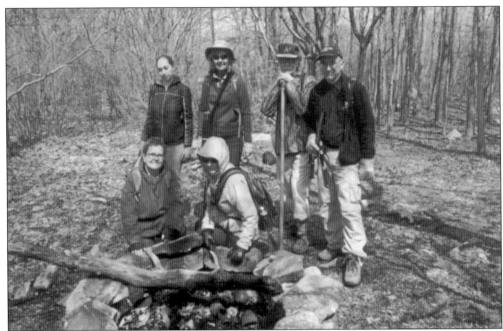

The Philadelphia Trail Club has been in continuous existence since formed in 1931. Members of the club maintain a little more than 10 miles of the AT from Lehigh Furnace Gap to Little Gap. During a work trip on April 6, 2013, a group of volunteers encountered a large and unsightly fire ring in a previously undisturbed area (above)—constructed by AT visitors who had not yet learned the Leave No Trace principles. To discourage further use of the site, the volunteers spent hours scattering the rocks, removing charred wood, and raking dirt and leaves onto the spot to leave it as natural looking as possible (below). (Both, courtesy of PTC.)

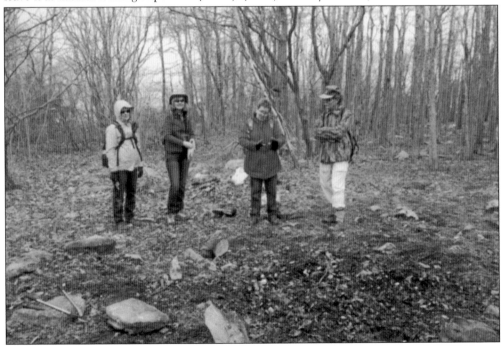

BHC member Allen Britton and his son Michael are pictured here on a Pennsylvania hiking trip in 1972. In 1928, the BATONA (BAck-TO-NAture) Hiking Club was established in Philadelphia and maintains nearly nine miles of the AT from Wind Gap to Fox Gap. Allen joined the club in the late 1970s and has been trails chairman, secretary-treasurer, and on BHC's Appalachian Trail Committee. (Courtesy of Allen Britton.)

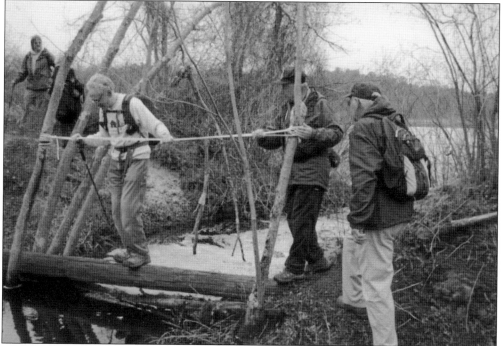

In addition to the AT, BHC also maintains sections of Pennsylvania's Horseshoe Trail. In 1961, under club president Morris Bardock, the club established the 49-mile Batona Trail through the Pine Barrens of New Jersey. Volunteers built a temporary footbridge and handrail to help them across a stream during a 2012 work trip to relocate a section of the latter trail in 2012. (Courtesy of BHC.)

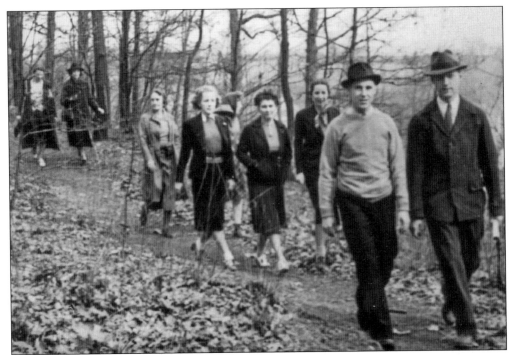

On March 31, 1939, Ted Darling sent a letter to those "imbued with the pioneering spirit" to attend a meeting at the Wilmington, Delaware, YMCA concerning a proposed hiking club. Within a few days, the group held a couple of hikes, the second of which was on April 15 along the Brandywine River and commemorated with the photograph above. Leading the group are Bill Friesendorf (left, first club program chair) and Howard Carter (right, first treasurer). The club took on the responsibility of maintaining seven miles of the AT from Fox Gap to Delaware Water Gap in the mid-1990s. WTC members recreated the historical 1939 photograph by dressing in period clothes (below) as they hiked along the Brandywine River on the club's 75th anniversary in 2014. (Both, courtesy of WTC.)

In 1941, WTC undertook development of the Brandywine Trail, a route of approximately 40 miles from Wilmington, Delaware, to the Horseshoe Trail near Bacton, Pennsylvania. The club took a hike on the pathway in 1943, at a time when many young men were away fighting in World War II. (Courtesy of WTC.)

Later in life, Benton MacKaye became concerned with a trend developing in the 1970s (and currently increasing) to hike the trail as quickly as possible. He felt it sullied his original purpose and said, "I hope the AT will never become a race track. But if so, I for one would vote to give the prize to the slowest traveler." (Courtesy of ATC.)

On April 6, 1951, almost three years after Earl Shaffer's historic hike, the trail's second thru-hiker, 24-year-old Gene Espey (left), met the trail's first southbound hiker, 28-year-old Chester Dziengielewski (below), at Smith Gap Shelter (no longer on the trail) in Pennsylvania. Dziengielewski had attempted a southbound thru-hike the year before, but he ran out of money before he was halfway done. The two exchanged notes and stories to learn about the portions of the trail each had not walked. Espy wrote about his trail and other travel experiences in his book *The Trail of My Life: The Gene Espy Story*, published in 2008. Dziengielewski passed away in 2002. (Left, courtesy of ATC; below, courtesy of Bill O'Brien.)

Walkin' Jim Stoltz received his nickname from more than 27,000 miles of hiking. In 1974, the AT introduced him to long-distance hiking and the ways of the natural world. After the AT, he walked across America and hiked the Continental Divide and Pacific Crest Trails. More often, he would make his own route, walking through the western states and from Yellowstone National Park to the Yukon in Canada. He returned from his journeys with songs and photographs about his experiences, the beautiful wilderness areas he had visited, and the creatures he came to admire and love. He toured across America, including performances for the 1989 ATC general meeting in East Stroudsburg, Pennsylvania and ALDHA gatherings. Stoltz's passion for the earth went beyond singing about it. He cofounded Musicians United to Sustain the Environment (MUSE), the Last, Best Place Wildlands Campaign, and coauthored the Northern Rockies Ecosystem Protection Act. The *Wall Street Journal* stated Jim had "more to say in one song than Frank Sinatra ever said in an entire concert." He passed away in 2010. (Courtesy of ATC.)

Soon after taking over responsibility to maintain a section of the AT, WTC improved and relocated a portion of that route. This 1995 photograph shows the herculean efforts volunteers put forth to keep the trail in hiking order. After harvesting a boulder from the ground, it was winched into place as part of a staircase. (Courtesy of WTC.)

Northbound hikers obtain their first good view of New Jersey from Mount Minsi. Orville Crowder (left) and Woody Kennedy took a hike to the vista during ATC's 15th general meeting in Delaware Water Gap from June 3 to 5, 1961. The Delaware River flowed through a topography older than the Appalachian Mountains' formation and, as the mountains rose, the river cut through, creating the water gap. (Courtesy of KTA.)

The AT descends from Mount Minsi into the Delaware Water Gap and passes by Lake Lenape. By the mid-1800s, the area had become a popular resort area with more than 40 hotels and other facilities catering to thousands of visitors. The lake has a *Twilight Zone* atmosphere today, but it was a well-liked canoeing spot when the trail was first routed by it in the early 1900s. (Courtesy of DWGNRA.)

One of the Delaware Water Gap's largest hotels was the Water Gap House, built on the lower slopes on Mount Minsi and opened in 1872. It had accommodations for more than 270 guests, and one its most famous was Theodore Roosevelt, pictured here in a postcard published by Hauser's Souvenir Store and printed in Germany. The facility burned in 1915; no trace of it remains. (Courtesy of DWGNRA.)

DEER HEAD INN, DELAWARE WATER GAP, PA.

Located on Main Street in Delaware Water Gap, the Deer Head Inn was established in 1869 and has furnished accommodations to generations of hikers, as it is directly on the AT's route where it descends from Lake Lenape and enters what used to be the heart of the resort area. The postcard was published by Landis and Alsop of Newark, New Jersey. (Courtesy of DWGNRA.)

NO MORE SHAD, OYSTERS, FARMS, FORESTS...

EAT AN ENGINEER FOR LUNCH, TOMORROW

NIX ON TOCKS

FUTURE POLLUTION LEVEL 430'

In the mid-1900s, the federal government began acquiring land, through purchase and eminent domain, for a flood-control project that included Tocks Island Dam. If built, it would have inundated large amounts of the Delaware River Valley. Public outcry stopped the project, and the acquired land was used to establish the Delaware Water Gap National Recreation Area in 1965. (Courtesy of DWGNRA.)

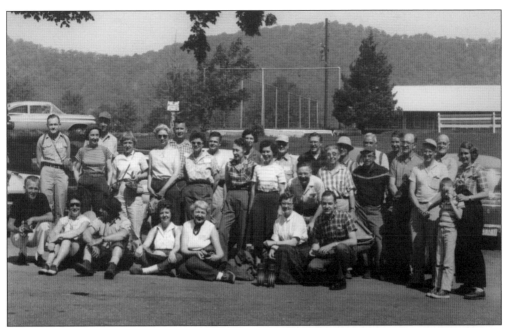

In June 1961, some of the 275 attendees of ATC's 15th general meeting in Delaware Water Gap pose for a photograph near the meeting's location, the Glenwood Hotel. The meetings are a combination of tending to the business matters that any organization has and a variety of workshops, hikes, and travel excursions. (Courtesy of ATC.)

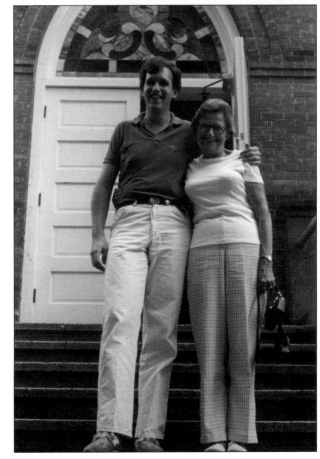

The Presbyterian Church of the Mountain's hostel is the AT's oldest church-sponsored hostel. It has been welcoming hikers since 1976 with a large gathering room, bunk room, and shower. Pastor Karen Nickels (right) was the friendly face that greeted hikers to the facility from 1988 to 2011. The other person is unidentified. (Courtesy of ATC.)

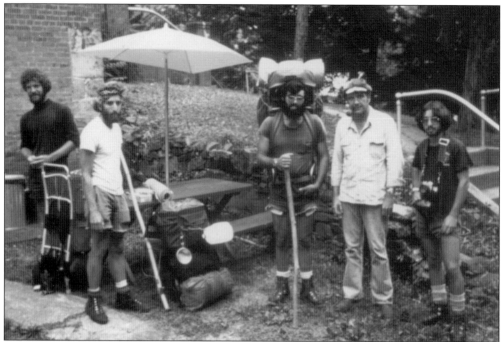

In 1977, Cletus Quick photographed some of the first hikers to stay at Delaware Water Gap's Presbyterian Church of the Mountain's hostel. From left to right are Doug Blaze and Gary Youngless (both from Florida), Ed Spataro (from Connecticut), Pastor Bill Cohea, and Cary Kish (from Maine). Blaze and Kish went on to become 2,000-milers that year. (Courtesy of ATC.)

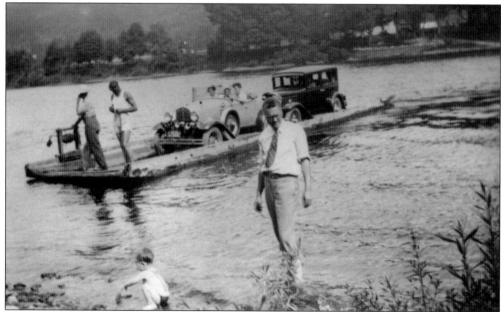

There was no one way to get across the Delaware River in the trail's early days. One guidebook suggestion was to make arrangements with a person living on the New Jersey side to carry one across in a canoe. Another suggestion was to use one of the many automobile ferries, some of which operated until 1937. (Courtesy of DWGNRA.)

A third option to crossing the Delaware River was for hikers to walk a roadway four miles eastward from the Delaware Water Gap village to the Portland-Columbia Covered Bridge and then walk roads another four miles to reach the AT on the New Jersey side of the river. The 1869 bridge was destroyed by flood in 1955. (Courtesy of Marty Dominy.)

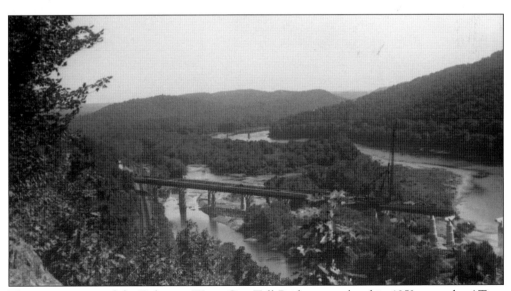

The construction of the Delaware Water Gap Toll Bridge, completed in 1953, gave the AT an easy way across the river. The bridge was originally built as a segment of a planned Pennsylvania freeway system, but it became part of I-80 in 1959. A wide pedestrian walkway on its southern side provides hikers with a safe way to enter New Jersey. (Courtesy of DWGNRA.)

DISCOVER THOUSANDS OF LOCAL HISTORY BOOKS
FEATURING MILLIONS OF VINTAGE IMAGES

Arcadia Publishing, the leading local history publisher in the United States, is committed to making history accessible and meaningful through publishing books that celebrate and preserve the heritage of America's people and places.

Find more books like this at
www.arcadiapublishing.com

Search for your hometown history, your old stomping grounds, and even your favorite sports team.